POSTCARD HISTORY SERIES

Brick Township

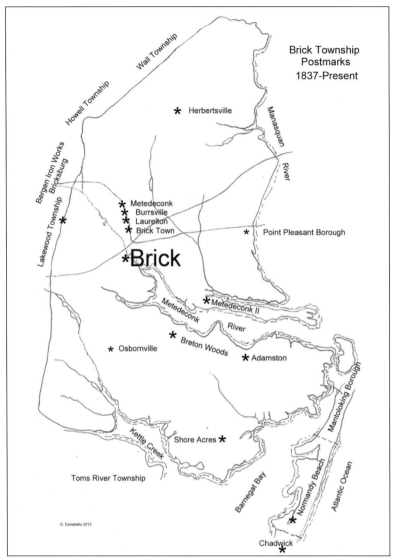

This map shows the various locations of post office postmarks in Brick Township from 1834 to present. (Courtesy of Gene Donatiello.)

ON THE FRONT COVER: Located on Cedarbridge-Adamston Road (now Mantoloking Road) was Charles Osborn's Royal Scarlet Store. The store grew as a result of the growth of the resort communities of Breton Woods and Cedarwood Park. It served as a grocery store, post office, and service station for its all year-round and summer residents. The store with its variety of products saved its customers from a five- to seven-mile trip to Point Pleasant or Toms River. (Courtesy of John Leavey.)

ON THE BACK COVER: Each resort community sponsored special events at various times of the year. There were baby parades, sailboat races, and foot races. On the Forth of July, there were parades of decorated bicycles and baby carriages marching through the community. In this postcard, young ladies take part in a beauty contest. In the background is the Metedeconk River and the north shore. (Courtesy of John Leavey.)

POSTCARD HISTORY SERIES

Brick Township

Gene Donatiello and John Leavey

ARCADIA
PUBLISHING

Copyright © 2013 by Gene Donatiello and John Leavey
ISBN 978-0-7385-9764-5

Published by Arcadia Publishing
Charleston, South Carolina

Printed in the United States of America

Library of Congress Control Number: 2012941004

For all general information contact Arcadia Publishing at:
Telephone 843-853-2070
Fax 843-853-0044
E-mail sales@arcadiapublishing.com
For customer service and orders:
Toll-Free 1-888-313-2665

Visit us on the Internet at www.arcadiapublishing.com

CONTENTS

ACKNOWLEDGMENTS

They were found in scrapbooks, old photo albums, desk and dresser drawers, shoeboxes, trunks, and suitcases; they are the memories saved in postcards by a previous generation. Those saved memories, whether from around the world, nation, state, or town, have allowed us to visit places we have never been. They have also allowed collectors of postcards to sit around for hours seeking that one postcard that is missing from their collection. Therefore, we thank those unknown people for preserving their memories.

We also thank people from the present like Kevin Hughes, Shirley Cooper, Walter Durrua, Margaret Peggy Osborn, and the Brick Township Historical Society for allowing us to use some of their collections in this book, and thanks to Greg Reissner for his technical assistance.

A special thanks goes to Lenora and Rosemarie for their assistance and support.

Unless otherwise noted, all images appear courtesy of the authors.

INTRODUCTION

In 1850, when the New Jersey State Legislature created Ocean County, New Jersey, from parts of Monmouth and Burlington Counties, it also created Brick Township from parts of Howell and Dover Townships. The new township was named for its most prominent citizen, Joseph W. Brick, the industrious owner of Bergen Iron Works. At the time it was created, Brick Township was made up of the villages of Adamston, Bricksburg (which became Lakewood in 1892), Bay Head (which became independent in 1888), Metedeconk (which became Burrsville and then Laurelton), Cedarbridge, Herbertsville, Osbornville, Point Pleasant Beach (which became independent in 1886), West Point Pleasant (which became independent in 1920), Mantoloking (which became independent in 1911), and finally, a portion of Normandy Beach.

Early industries in Brick Township included lumber, pinewood (charcoal and turpentine), two iron forges, and cranberry, blueberry, and poultry farming. The people of Brick Township made their living from the land, bay, rivers, and forests. They were subsistence farmers growing their own food and trading off the surplus. They fished and hunted the rivers, bay, ocean, and forests. There was an abundance of striped bass, perch, herring, crabs, and clams, along with deer, ducks, rabbits, pheasants, and grouse.

Brick Township saw a decline in prosperity by the end of the 19th and beginning of the 20th centuries. The Pennsylvania and New York & Long Branch Railroads, which brought tourism to Lakewood and Point Pleasant, had bypassed Brick Township. The opening of the canal linking the Manasquan River to Barnegat Bay had introduced saltwater to the upper bay, destroying the spawning area for fish and the freshwater supply used for cranberry cultivation; however, in the 1920s, a turnaround took place. The national economy had been good, and people were looking to spend their newfound wealth. New economies came to the area, and summer camps for children began to spring up, including Camp Eagle, Boy Scout Camp Burton, Princeton Summer Camp, Camp Metedeconk, New Jersey Episcopal Choir Camp (NEJECHO), and the Cedars, a camp for special-needs children. Meanwhile, in the lake country of northern New Jersey, the sale of homes in resort communities was very successful. Resort communities provided beaches, docks for boats, clubhouses, and other amenities for those who purchased a lot and house. Likewise, in southern New Jersey, Brick Township was the ideal place for construction of resort communities, with ample land, pristine forests, the Manasquan and Metedeconk Rivers, Kettle Creek, Barnegat Bay, and the Atlantic Ocean.

Up to the 1920s, the few postcards of Brick Township consisted of pictures of churches, bridges, roads, and general stores. The building of resort communities, starting in the 1920s, added a new topic for picture postcards. From 1837 to 1978, there was never an official postmark

for Brick. All the small villages and some of the resort communities had their own postmarks, which totaled 16, creating confusion for mail delivery. It currently also causes confusion for postcard dealers and collectors.

Though the camps are gone and the resort communities are slowly being converted to year-round communities, they still maintain their beaches, docks, and clubhouses. The camps and resort communities added to the local economy and brought about business, as well as the need for infrastructure improvements and municipal services. The new residents introduced new ethnic groups and religions to the area. These camps, resort communities, businesses, and services will be depicted in our postcard book.

Today, Brick Township includes a mixture of summer resorts, year-round homes, 13 adult communities, an industrial park, and a hospital and is the commercial center for many surrounding communities. It covers 26.2 square miles of land and 6 square miles of water, has a population of 75,072, and is the 13th largest community by population in the state of New Jersey.

Postmarks used for Brick Township, 1848–Present:

Adamston	1900–1946
Bergen Iron Works	1848–1865
Bricksburg	1865–1892
Breton Woods	1937–1958
Brick	1978–Present
Brick Town	1959–1978
Burrsville	1884–1914
Chadwick	1882–1929
Normandy Beach	1929–Present
Herbertsville	1884–1938
Laurelton	1914–1959
Metedeconk	1837–1884
Metedeconk II	1941–1959
Osbornville (Osborn)	1879–1960
Shore Acres	1948–1960
Point Pleasant	1834–1892

One

ADAMSTON
1900–1946

The area serviced by the Adamston Post Office centered on George Adams's general store along Cedar Bridge–Adamston Road (now Mantoloking Road) out to Barnegat Bay. The post office was established here in 1900. The Adamston Post Office remained in the general store through three successive owners and postmasters. In 1938, the post office was moved to Sam Wooley's Purol service station on Cedar Bridge–Adamston Road, where Wooley served as postmaster. The Adamston Post Office serviced communities on Metedeconk Neck, like Nejecho Beach, Sandy Point, Hulse Landing, Eagle Point, Metedeconk Pines, and West Mantoloking. In 1939, Wooley's son Tom took over as postmaster. Two years later, Tom Wooley was off to fight in World War II, and his wife, Helen, took over running the post office and service station. Two years after Tom returned from his military service to the postmaster's job, the post office closed in 1946, and the Breton Woods and Osbornville Post Offices took over handling the mail for Adamston.

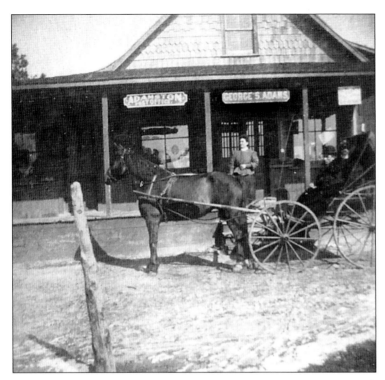

In the late 1800s, George Adams opened his general store on Cedar Bridge Road, later renamed Mantoloking Road. The store carried groceries, newspapers, and tobacco, and George took catalog orders. The store also served as a post office, using the postmark Adamston with George Adams as postmaster. The area around the store became known as Adamston. (Courtesy of Brick Township Historical Society.)

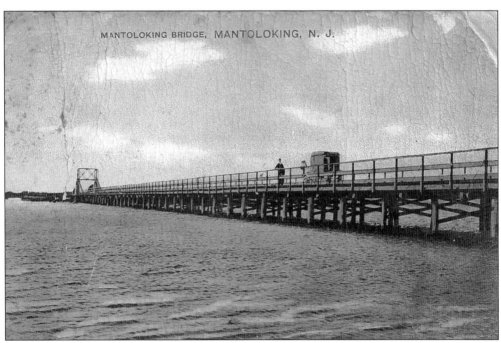

This is the first of four bridges from Brick Township across Barnegat Bay to the township's property on the peninsula area. The bridge had a wood-plank causeway, and the draw span was hand operated. There was not always a bridge tender on duty, so on occasion, bay travelers had to operate the bridge themselves.

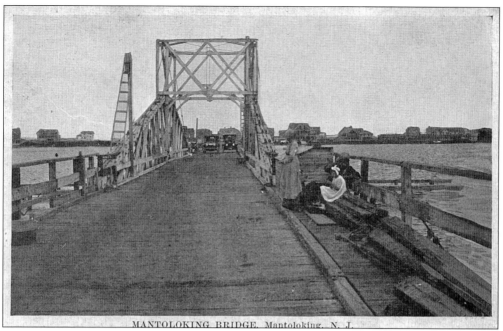

The second bridge crossing Barnegat Bay from Brick Township to its property on the peninsula area used the original wood-plank causeway The story passed down was that when the bridge tender went to lunch at Uncle Jakey's, which was on the peninsula side, boys from the west bank would sneak out and open the bridge, leaving the bridge tender stranded on the opposite side.

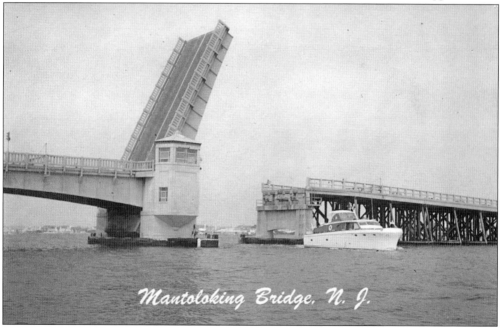

The third bridge crossing Barnegat Bay from Brick Township to the present Borough of Mantoloking was an electric-powered, mechanically operated drawbridge. This bridge, built in 1937, was a project of the Works Progress Administration (WPA). The WPA was a federal government program that put people to work during the Great Depression of the 1930s.

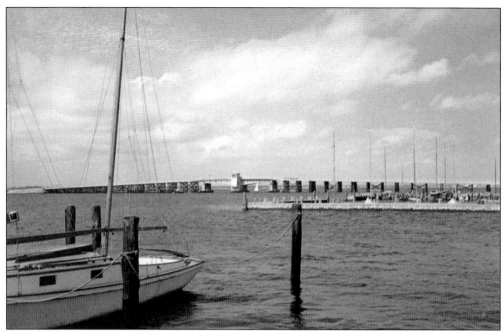

The fourth bridge crossing Barnegat Bay to the Borough of Mantoloking was built just north of the 1937 bridge and opened in 2002. This totally new bridge with a higher elevation and modern draw opening did not have to open as frequently for boats traveling the Intracoastal Waterway through Barnegat Bay.

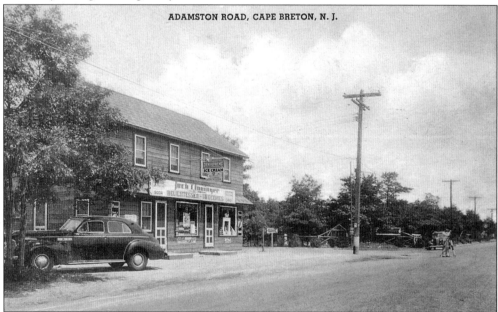

ADAMSTON ROAD, CAPE BRETON, N. J.

Jack Cluninger's Deli and Grocery Store is on the corners of Adamston Road and Bretonian Drive. Cluninger advertised his store as selling meats, fancy groceries, fruits, and vegetables. The Collotype Co. of Elizabeth, New Jersey, made this postcard for sale at his store. The hand-written message on the back reads, "Spent August 6, 7, 8, 1943 with the Miller family at their summer home; had a wonderful time fishing and bathing."

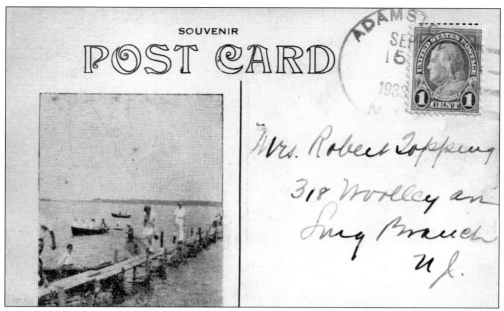

This postcard, cancelled with the Adamston postmark on September 15, 1933, identifies that it was mailed from George Adams's general store. Though the picture on the postcard is of the dock at Camp NEJECHO, it may not necessarily have been sent by one of the campers. During the off-season, the buildings, docks, and boats at Camp NEJECHO were maintained by Charlie Maxon and his nephew Sam Morris.

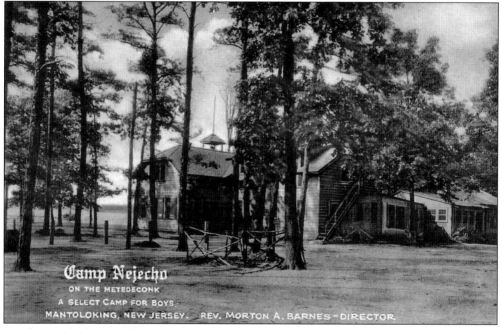

On the south shore of the Metedeconk River was the New Jersey Episcopal Choir Camp, commonly known as NEJECHO. The camp provided a summer getaway for boys and girls who participated in their church choir. The camp was the idea of Rev. Elliot White, who started the camp in 1907 and spent 19 years running it. (Courtesy of Kevin Hughes.)

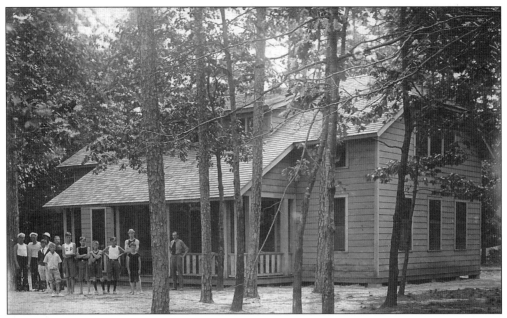

Camp NEJECHO had several buildings; pictured here is the main dormitory for campers. There were counselors' cabins and a meeting and dining hall called Trinity Chapel. Trinity Chapel was moved to Camp NEJECHO in 1934 from Princeton, New Jersey. In 1940, the camp property was sold to the newly formed Nejecho Corporation, which developed a community of private homes called Nejecho Beach Club. (Courtesy of Kevin Hughes.)

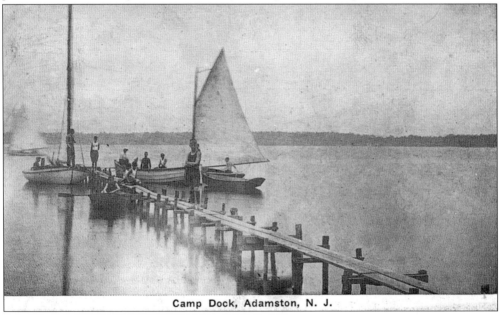

Camp Dock, Adamston, N. J.

The long, narrow dock at Camp NEJECHO was the center for all water activities; there were swimming lessons and sailing instructions, and usually, there was a number of rowboats tied up. Jean Miller LaVance lived just east of NEJECHO and recalls that the boys were allowed to row out into the river as far as buoy no. 6, and in the evening, the local teenage girls would row out to meet them there.

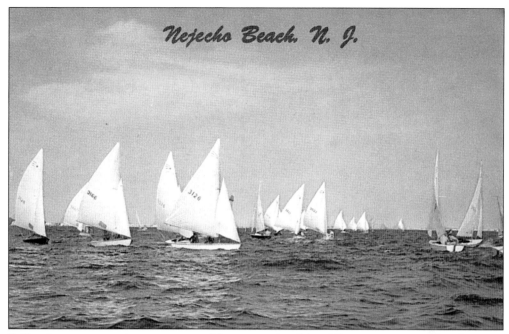

Nejecho Beach, N. J.

Sailing lessons were an important part of the campers' training. There were competitions between campers and with other camps along the Metedeconk River. One of the big competitions was between Camp NEJECHO and Princeton Summer Camp across the river on the north shore.

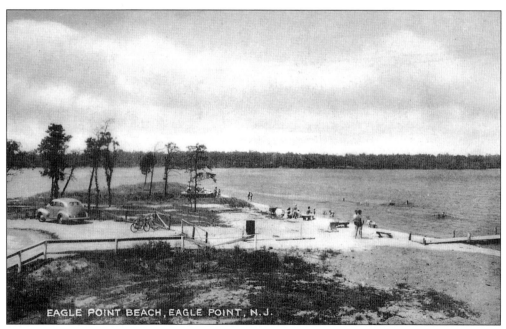

EAGLE POINT BEACH, EAGLE POINT, N.J.

Situated on a point jutting out from the south shore into the Metedeconk River is Eagle Point. Once known as "Zek'sl P'int," it was the site of many evangelical meetings. In the late 1920s, the property was purchased by Joseph M. Child of Deal, New Jersey. Child converted the evangelical camp into a summer camp for boys and girls, calling it Camp Eagle.

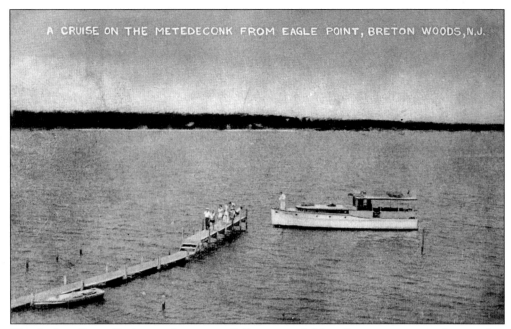

The dock at Camp Eagle was the center of all water activities. Campers were taught to swim, fish, and navigate sailboats. The camp operated as two camps. During the month of July, it was a girls' camp, and during the month of August, it was a boys' camp.

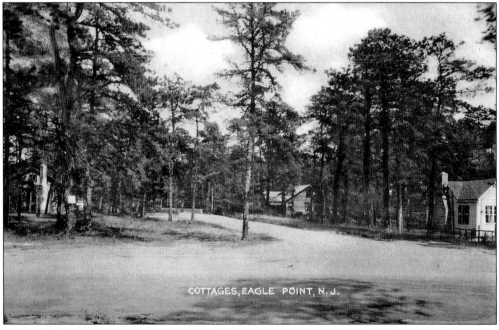

Camp Eagle continued to operate until 1938. At that time, Joseph Child teamed with a Mr. McKinley and subdivided the campsite into building lots, calling the new subdivision Eagle Point Reservation. The lots were sold off, allowing lot owners to build their own cottages.

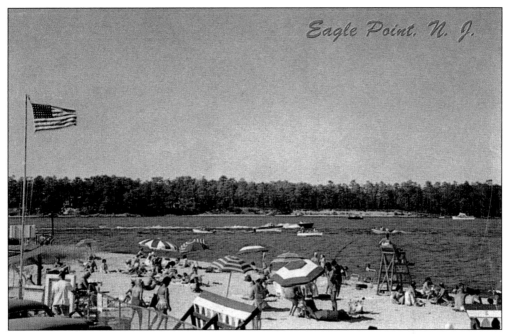

The beach at Eagle Point Reservation was under the direction of the Eagle Point Reservation Association, which was made up of homeowners. The association oversees the maintenance of the beach and other amenities.

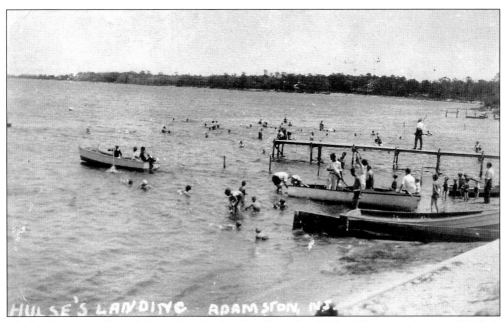

The beach pictured here belonged to the family of Russling Hulse. The privately owned Hulse's Landing was only for vacationers staying in the Hulse cottages or for those who purchased a daily entrance ticket.

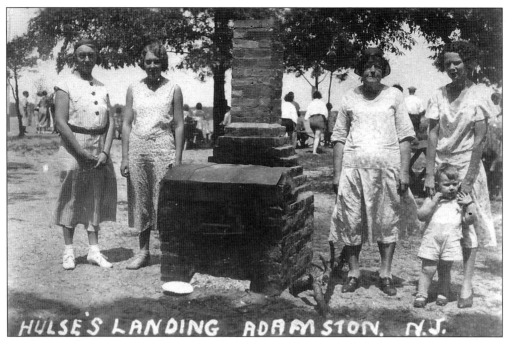

HULSE'S LANDING ADAMSTON, N.J.

Cooking in the cottages was limited and heated up the house in the summertime, so barbecue pits were scattered through the area for outside cooking.

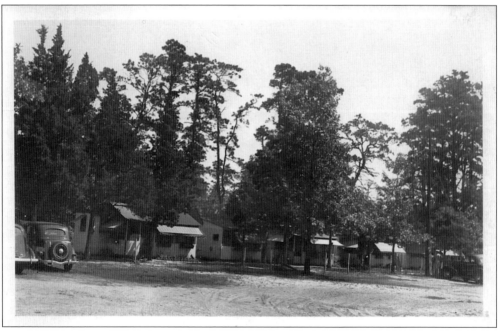

Cottages at Hulse's Landing, seen here, were rented by the week or longer. (Courtesy of Kevin Hughes.)

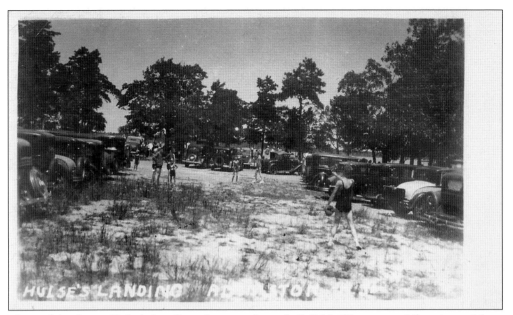

The parking lot at Hulse's Landing also served as a ball field. The automobiles pictured here date this postcard to the 1930s. (Courtesy of Kevin Hughes.)

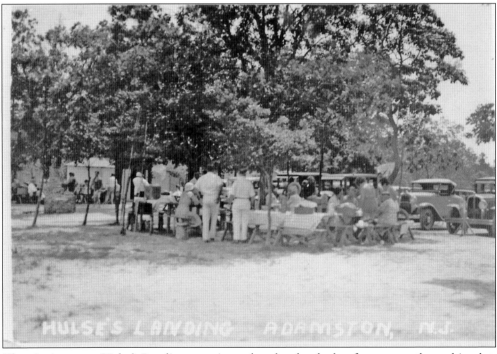

The picnic area at Hulse's Landing was situated under the shade of trees near the parking lot. The automobiles date this postcard to the 1920s. (Courtesy of Shirley Cooper.)

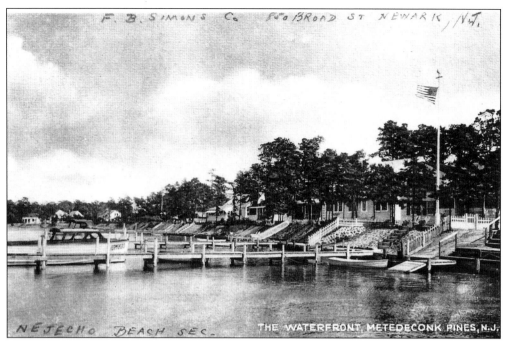

On the south shore of the Metedeconk River, on a rise above Kingfisher Cove, was the summer resort of Metedeconk Pines; like most of the resort areas, many of the summer homes have been converted for year-round living.

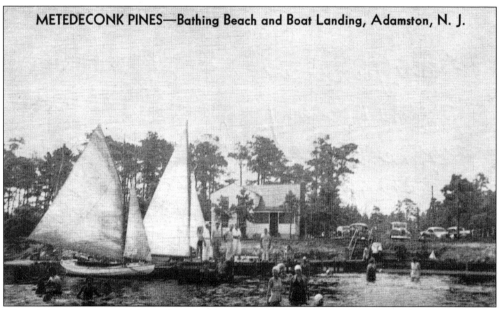

The subdivision map for Metedeconk Pines was filed in 1926. This postcard of Metedeconk Pines was used by the developer for promoting his development.

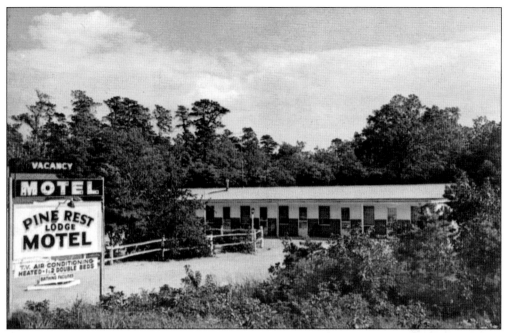

The Pine Rest Lodge Motel, located at 531 Mantoloking Road, was owned and operated by the Rodriguez family. The motel offered guests one- and two-bed units, free ocean bathing, a television in each room, and heat and air-conditioning. The Pine Rest Motel was about three miles from the Atlantic Ocean.

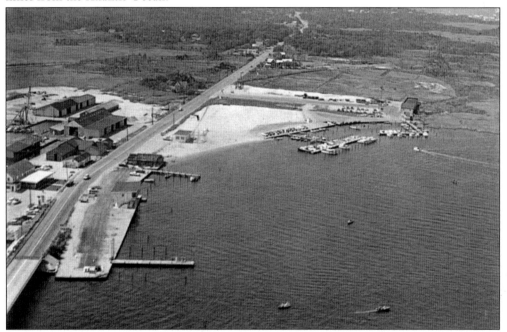

At the eastern end of and on the north side of Mantoloking Road just before the bridge was Pleasure Cove Marina. This 1960s postcard shows the road to the bridge in the lower left and, to its right, the old road to a former bridge. Presently, Pleasure Cove is known as Brick Township's Traders Cove.

With the increase in summer population, there was a need for an additional first-aid squad. In 1943, a group of volunteers from Adamston and Breton Woods formed the Community First Aid and Emergency Squad. The squad, located on Mantoloking Road, passed out this card for emergency uses and to promote its services. (Courtesy of the Brick Township Historical Society.)

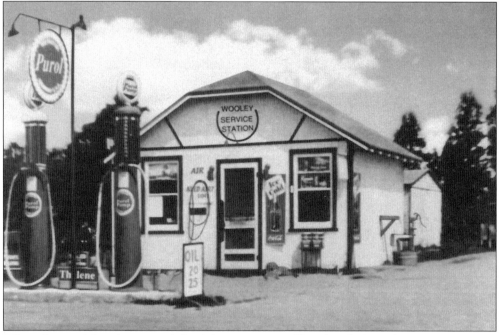

When George Adams's store and the Adamston Post Office closed, the Adamston Post Office was moved to Tom Wooley's Purol service station on Mantoloking Road. Besides running the service station, Wooley served as postmaster and was a volunteer with Community First Aid and Emergency Squad. When Wooley went out on calls, his wife, Helen, took over running the post office and service station.

Two

BRETON WOODS
1937–1958

In the early 1930s, Howard Van Ness set up Van Ness Corporation and began acquiring land along the south shore of the Metedeconk River. His plans called for developing a summer resort community of cabins with a beach on the river along with a clubhouse and docks for boats. One of Van Ness's land acquisitions was the former Boy Scout Camp Burton, adjacent to his Breton Woods development. With the camp purchase, he acquired the camp dining hall, which he moved down to the water's edge to be used as a clubhouse. Along with Breton Woods, Van Ness built similar colonies at Cape Breton and Vanada Woods. He, along with Harris and Company, developed Breton Harbor, Mariners Cove, and Baywood Estates. There are more than 400 homes now. In 1937, a post office using the postmark Breton Woods was set up in Charles A. Osborn's Royal Scarlet Store on Mantoloking Road to serve the resort communities. Osborn served as postmaster. Besides the communities of Breton Woods, Cape Breton, Breton Harbor, and Mariners Cove, the Breton Woods Post Office also served Cedarwood Park and Cedar Bridge. The Breton Woods Post Office continued to operate until 1958.

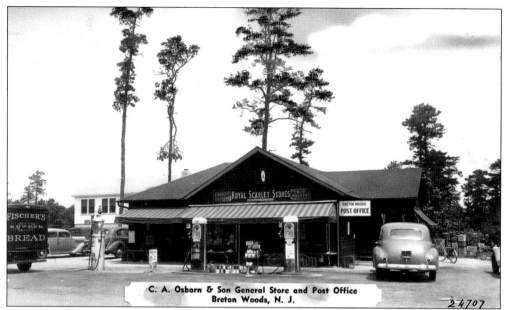

C. A. Osborn & Son General Store and Post Office
Breton Woods, N. J.

24707

Located on Cedarbridge–Adamston Road (Mantoloking Road) was Charles Osborn's Royal Scarlet Store. The store grew because of the growth of the resorts of Breton Woods and Cedarwood Park. The store sold groceries, vegetables, and meats; Becky Osborn was the butcher. The store also carried Honor Brand Frosted Foods and promised prompt delivery for solicited orders. The Breton Woods Post Office was also located in the store. (Courtesy of Brick Township Historical Society.)

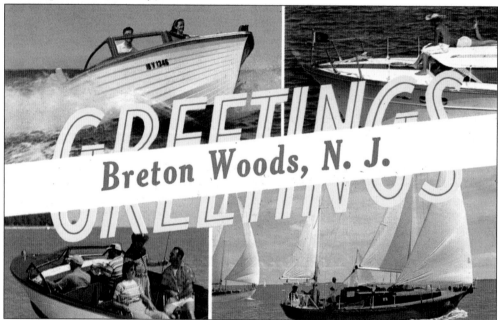

Howard Van Ness, a sales agent for the defunct Coast Finance Company at Riviera Beach on the Manasquan, created his own company—the Van Ness Corporation—and in the early 1930s, he began purchasing land on the south side of the Metedeconk River for his summer resort development at Breton Woods.

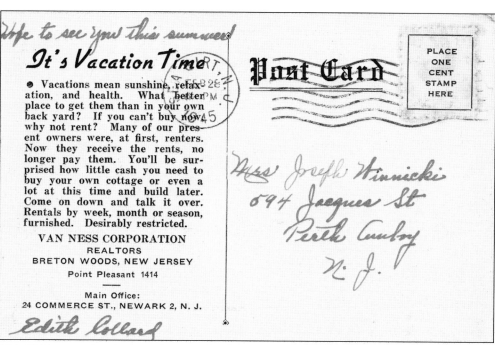

Hope to see you this summer!

It's Vacation Time

● Vacations mean sunshine, relaxation, and health. What better place to get them than in your own back yard? If you can't buy now, why not rent? Many of our present owners were, at first, renters. Now they receive the rents, no longer pay them. You'll be surprised how little cash you need to buy your own cottage or even a lot at this time and build later. Come on down and talk it over. Rentals by week, month or season, furnished. Desirably restricted.

VAN NESS CORPORATION
REALTORS
BRETON WOODS, NEW JERSEY
Point Pleasant 1414

—

Main Office:
24 COMMERCE ST., NEWARK 2, N. J.

Edith Collard

Post Card

PLACE
ONE
CENT
STAMP
HERE

Mrs Joseph Winnicki
594 Jacques St
Perth Amboy
N. J.

This 1945 promotional postcard sent out by the Van Ness Corporation advertised the availability of lots to construct on later or rent cottages as a way to experience the relaxed atmosphere of Howard Van Ness's summer resort communities. The card also proposes purchasing property and renting it out to other vacationers. The last sentence explains it all: "Desirably restricted."

R. R. STATION, BAY HEAD, N. J.

With no railroad service to Brick Township, in order to attract more buyers, developers offered free transportation from the railroad stations in Bay Head Borough and Point Pleasant Beach Borough to their resort communities in Brick Township.

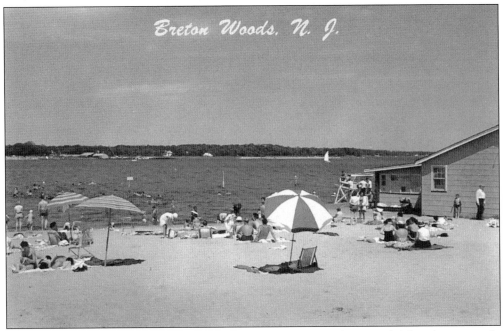

Breton Woods, N. J.

This is the front side of the Van Ness Corporation promotional postcard. The view not only shows the beach and people enjoying the water but also the left rear corner of the clubhouse. In the background across the Metedeconk River is the north shore of the river.

BRETON WOODS, N. J.

The Metedeconk River was well known for fishing and crabbing. Upstream, north of State Highway 70, is freshwater for fishing for perch, bass, and trout; downstream toward Barnegat Bay, crabs, flounders, snapper blues, weakfish, and blowfish can be found.

BRETON WOODS, N. J. 4A-H894

Arthur Dickerson from Metedeconk Bathing Beach used his 40-foot speedboat *Mary Ann* for sightseeing along the Metedeconk River. For a nominal fee, he picked up customers from the various resorts along the river and toured the Metedeconk and Barnegat Bay.

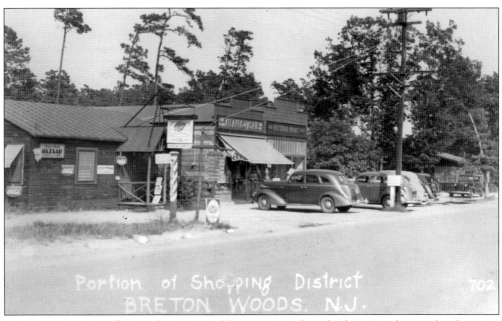

On the north side of Mantoloking Road between Dock and Altier Roads was the shopping area for Breton Woods and the surrounding area. Located here was the Breton Woods Bazaar, a popular gathering spot. Residents could purchase soup and sandwiches, ice cream, newspapers, and magazines. There was the Womrath Lending Library, where books were rented for 10¢ for the first three days and 3¢ per day thereafter.

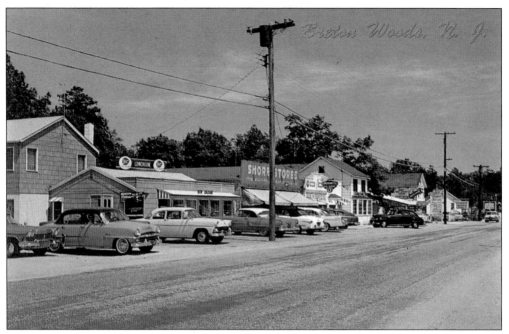

The Breton Woods shopping area, established in the 1930s, has remained active for over 80 years. Pictured here is the Breton Woods shopping area with 1950s cars parked in front of the shops.

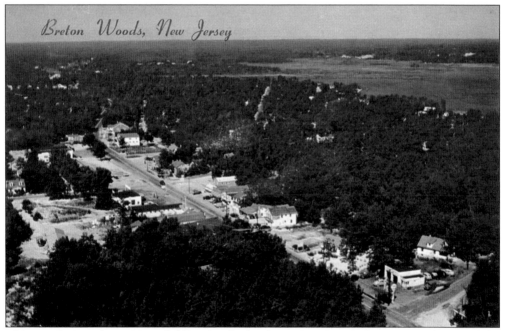

This aerial view shows Mantoloking Road, also known as Ocean County Road 528, in the lower left corner; the Breton Woods business district in the center; and the Metedeconk River in the upper-right background.

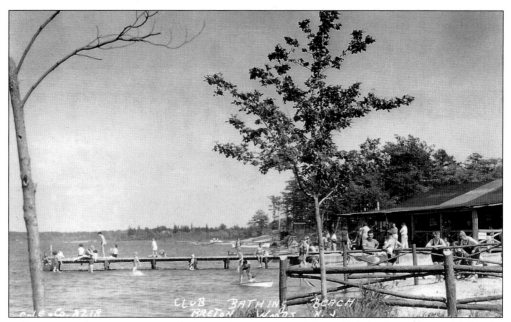

When Howard Van Ness started construction at Breton Woods, he was not prepared for the rapid growth of the community. As a result, he purchased the old Boy Scout Camp Burton, adjacent to his development, and moved the Scouts' all-purpose building down to the water's edge to supplement the original clubhouse.

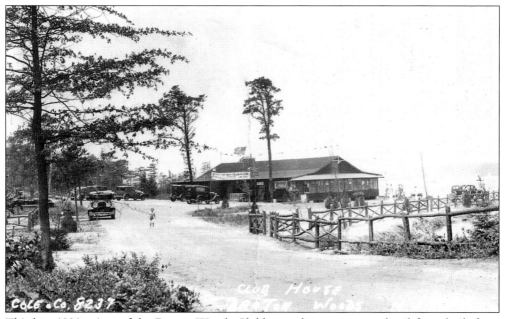

This late-1930s view of the Breton Woods Clubhouse shows a post-and-rail fence built from local cedar trees.

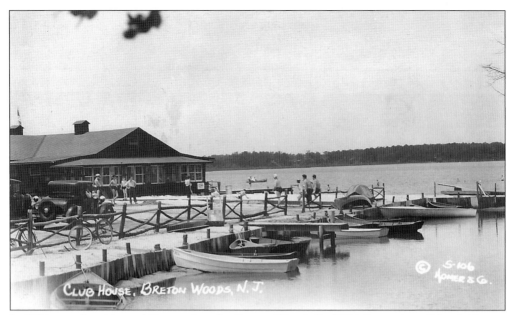

In 1936, a rustic cabin could be purchased at Breton Woods for $895. Expansion of the clubhouse was needed to accommodate the new residents. The Breton Woods Clubhouse had an enclosed porch added to the left side.

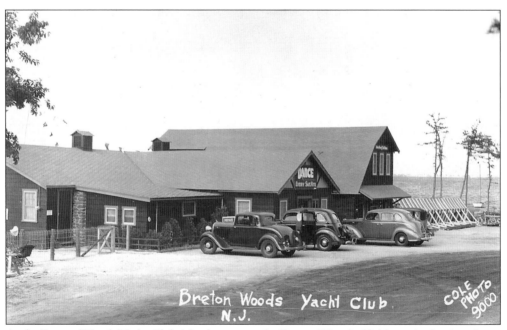

At the Breton Woods Yacht Club (also known as the Breton Woods Clubhouse), the sign above the door reads, "Dance Sat. Nite." Note the automobiles in front of the clubhouse. This image was captured in the 1930s during the Great Depression, and at Breton Woods, people continue to buy summer homes and drive relatively new automobiles.

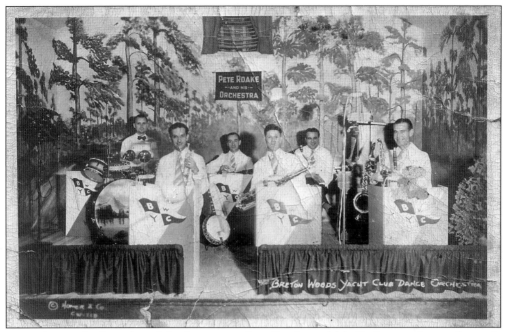

Appearing at the Saturday night dances was Pete Roake and his Orchestra; the music stands carry the Breton Woods Yacht Club logo. The painted pine trees in the background give a local look to the stage. (Courtesy of Kevin Hughes.)

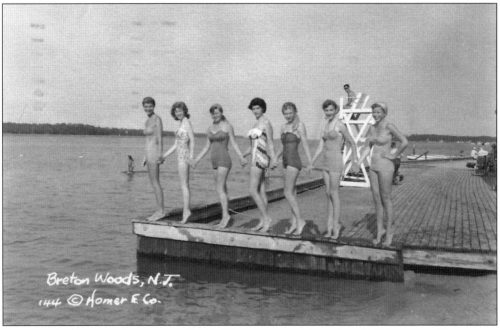

Every resort community sponsored special events at various times of the year. There were baby parades, sailboat races, and foot races. Independence Day was celebrated with parades of red, white, and blue decorated bicycles, wagons, and baby carriages parading throughout the community. On this postcard, ladies take part in a beauty contest at Breton Woods. The Metedeconk River and its north shore can be seen in the background.

The beach, dock, and playground were a favorite setting for photographers when taking pictures of the local young ladies.

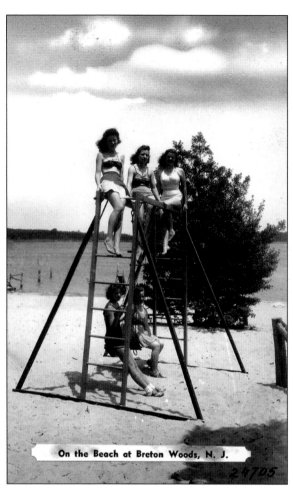

On the Beach at Breton Woods, N. J.

The Breton Woods beach can be seen here from the dock of the Breton Woods Yacht Club. In the background are the Metedeconk River and the north shore line.

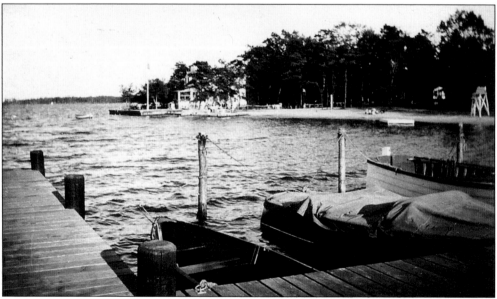

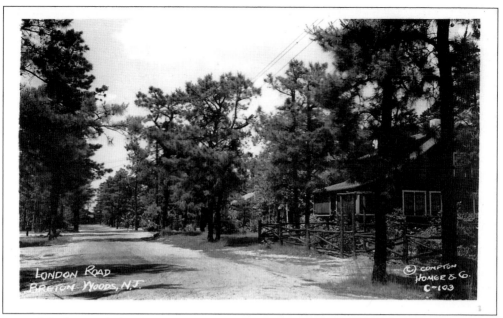

One of the last roads heading east in Breton Woods was London Road. The road runs from Cedarbridge Road (now Mantoloking Road) to the Metedeconk River. The cottages built here were mostly two-story buildings, as compared to the one-story cottages first erected in Breton Woods. Most of the cottages have been expanded over the years; only a few remain original. (Courtesy of Kevin Hughes.)

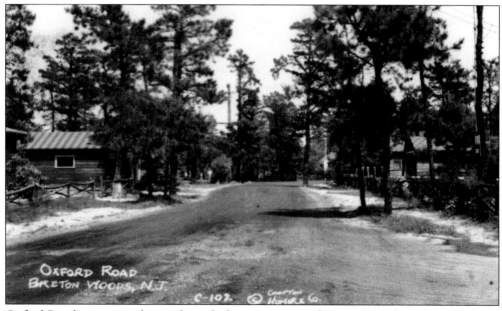

Oxford Road ran east and west through the community of Breton Woods, linking the north and south roads together.

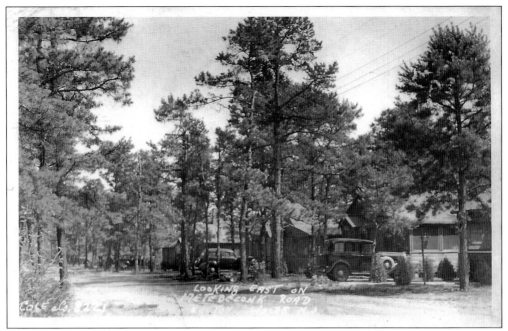

In most cases, getting from one summer resort to another required using Cedarbridge Road. The interior roads of these summer resorts were not connected. Each acted as its own little community. This postcard was taken looking east along Cedarbridge Road. (Courtesy of Kevin Hughes.)

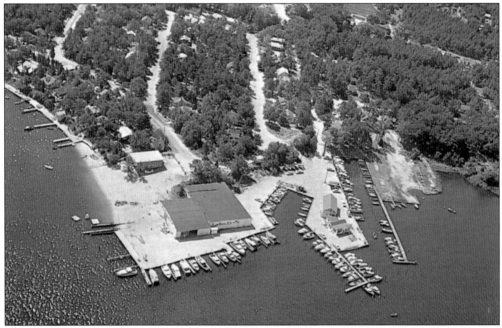

This aerial view of Breton Woods faces southeast and shows the road leading to the Metedeconk River and Wooley's Boat Basin. Wooleys offered dockage, winter storage, boat repairs, and supplies and used either railway or crane service. Presently, Wooley's Boat Basin is Cassidy's Boatyard.

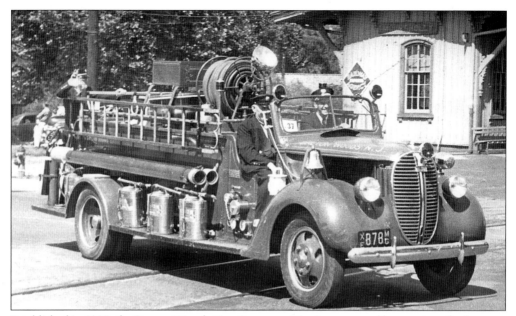

Established in 1935, the Breton Woods Fire Company No. 1 was started by a group of volunteers who saw the need as the number of developments in the area increased. Also, there was always the threat from forest fires, which had taken many homes in the past. This postcard shows a Breton Woods fire truck at a parade in Mount Holly, New Jersey.

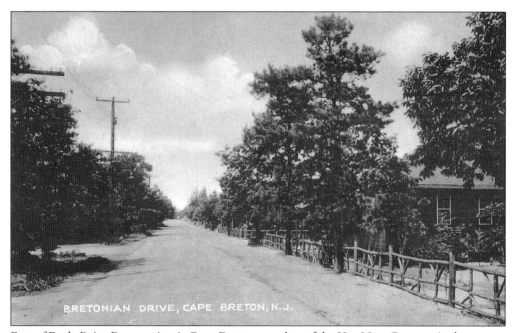

BRETONIAN DRIVE, CAPE BRETON, N.J.

East of Eagle Point Reservation is Cape Breton, another of the Van Ness Corporation's summer resorts. Bretonian Drive is the main road leading into Cape Breton. It was a sand road, as were all the side roads at this time.

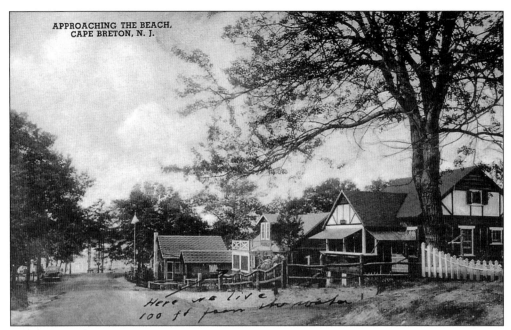

APPROACHING THE BEACH,
CAPE BRETON, N. J.

Here we live
100 ft from the water

On the road leading down to the beach at the Van Ness Corporation's Cape Breton Resort, the variety of cottage styles built by the summer residents can be seen. Most of the homes at the Van Ness developments were pre-cut homes manufactured by American Homes, which was also owned by Howard Van Ness.

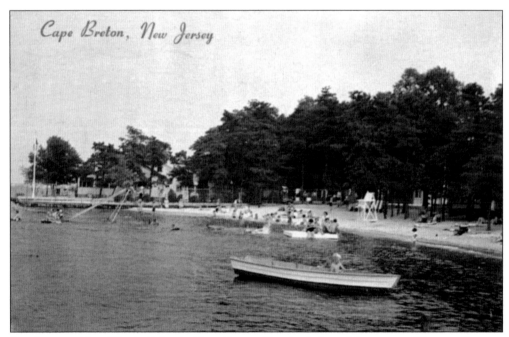

Cape Breton, New Jersey

On the east side of Eagle Point is Cape Breton Beach, sheltered in a cove. The tree line ran almost down to the water's edge. The river water was shallow and calm, safe for young children. There was a lifeguard on duty who could survey the entire beach from one location.

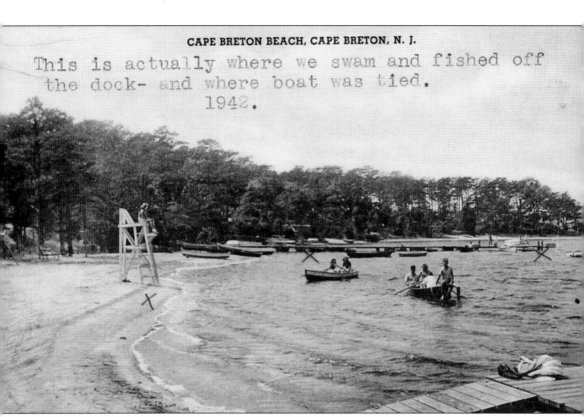

CAPE BRETON BEACH, CAPE BRETON, N. J.

This is actually where we swam and fished off the dock- and where boat was tied.
1942.

The writer of this Cape Breton postcard made certain the recipient knew each location on the beach that they had visited. (Courtesy of Kevin Hughes.)

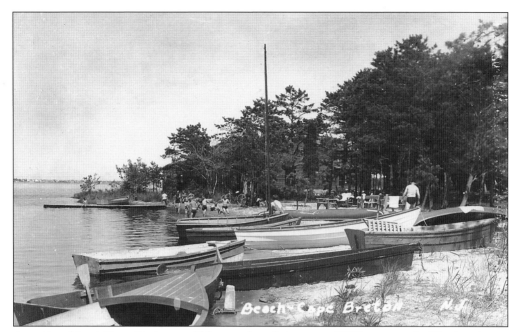

A rustic cabin at Cape Breton could be purchased at a cost of $25 per month. The beach was long and narrow; however, there was little dockage, and most residents beached their boats.

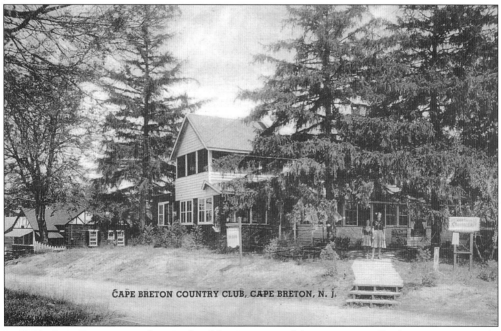

In 1950, Cape Breton was advertised as "the Country Club Community," where a person could "stay young, healthy, and happy by enjoying 52 vacations year round at Cape Breton."

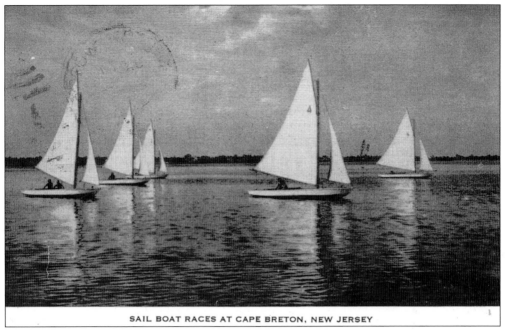

SAIL BOAT RACES AT CAPE BRETON, NEW JERSEY

At Cape Breton, as well as at the other resort communities along the Metedeconk River, sailing was a major part of community activities. Saturday mornings were competition days, when young sailors got to compete with their neighbors as well as those from other resort communities.

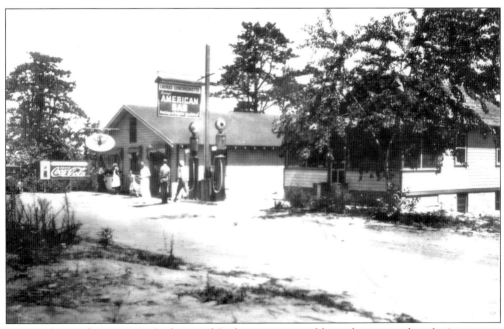

At Laura's Luncheonette in Cedarwood Park, a person could purchase a meal, soda, ice cream, and gasoline or rent a cottage. Not far from Laura's, there were plans to build the Cedarwood Park Hotel. Stocks in the hotel were sold for $25 a share; lumber was delivered, but the hotel was never built. The lumber was eventually scavenged by home and shop builders.

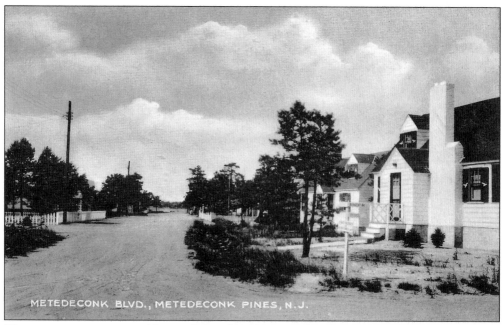

METEDECONK BLVD., METEDECONK PINES, N.J.

The many resort communities tended to blend into each other. Little Metedeconk Pines is overshadowed by the much larger Breton Woods, and the only way to identify the smaller communities is by the main road leading into the resort.

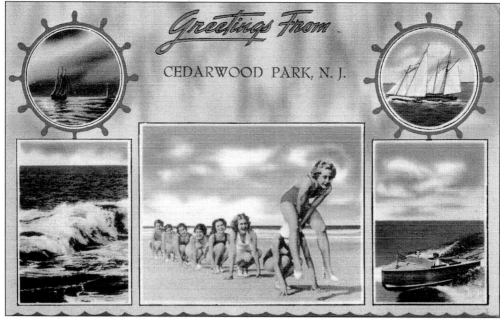

Greetings From CEDARWOOD PARK, N.J.

In 1928, the *Hudson Dispatch*, a Union City newspaper, purchased several hundred acres of land on the south side of the Cedar Bridge branch of the Metedeconk River. The *Dispatch* had the land subdivided in 20-foot-by-100-foot lots. Naming its creation Cedarwood Park, it gave away one lot with each new subscription to its newspaper. Two lots were needed in order to build a cottage.

Built with a six-foot concrete wall all around, this compound was the cause of many rumors. One rumor claims it was a nudist colony—a rumor that is still around today. Another rumor was that this was the Cedarwood Hotel, which was never built. (Courtesy of Kevin Hughes.)

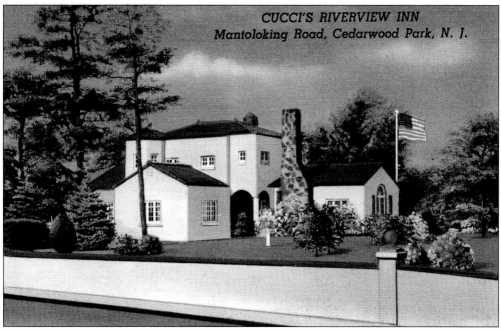

This postcard shows Cucci's Riverview Inn on Mantoloking Road. Cucci's Restaurant offered fine wines, beers, liquors, package goods, and excellent cuisine. On the reverse side of the card were directions for getting to the inn from Jersey City and New York.

This is an example of the typical American-style bungalow built between 1905 and 1950. These bungalows, usually constructed by individual homeowners, were larger than the typical cottages in most resort communities. The bungalow on this postcard was erected by a resident in Cedarwood Park.

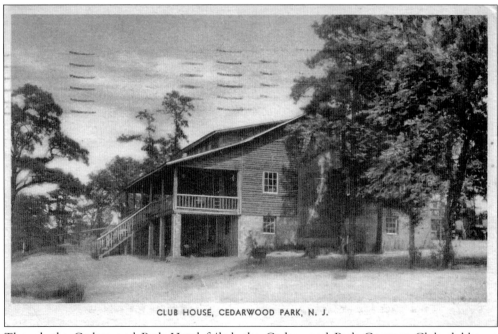

Though the Cedarwood Park Hotel failed, the Cedarwood Park Country Club clubhouse was built. Membership was limited to property-holding residents. An initiation fee of $75 was required with $15 annual dues. This allowed the property owner and guest to use the clubhouse and beach.

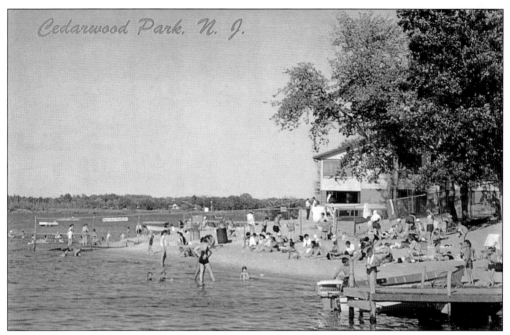

The resort communities were very protective of their beaches. Pictured in the background is the Cedarwood Park Country Club clubhouse and beach. In the foreground is another beach; note the chain-link fence dividing the two beaches. The Cedarwood Park Country Club clubhouse was eventually converted into a private home.

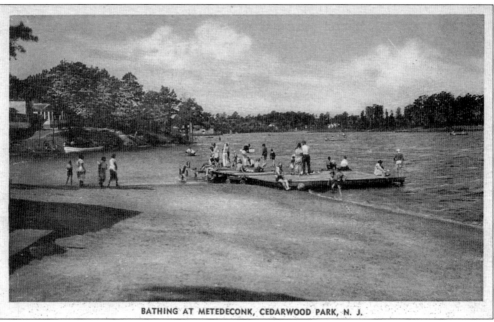

This image looks west up the Cedar Bridge branch of the Metedeconk River, with the Cedarwood Park bathing beach in the foreground; it was at about this point that the pre–American Revolutionary War village of Cedar Bridge was located. It was also the location of docks that carried goods to and from the surrounding villages.

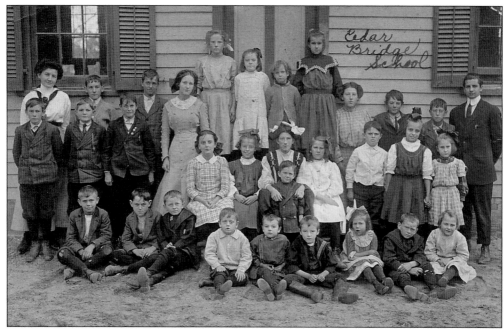

The Cedar Bridge School was located in the village of Cedar Bridge. The school housed first through eighth grades. Any student wishing to go to high school had to attend Point Pleasant Beach High School. The school had two teachers, and the number of students varied each year.

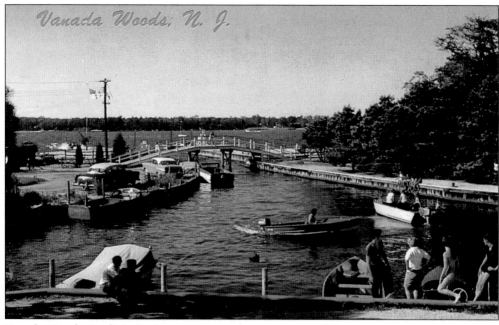

Vanada Woods, Eagle Point Reservation, and Cape Breton all shared Eagle Point, each having its own beach and activities. Vanada Woods was established in 1939 by the Vanard Corporation. Vanard Harbor, pictured here, was the hub of boating activities. Homes were built on each side of the harbor, making it the center of the community.

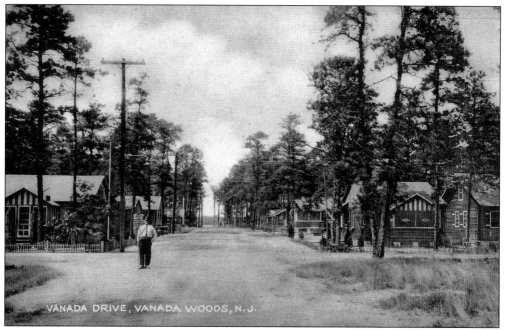

The main street in Vanada Woods was Vanada Drive, with cottages lining the drive down toward the harbor. Standing in the middle of the road is the town constable; at that time, he comprised the entire law enforcement for the community and was employed by the township.

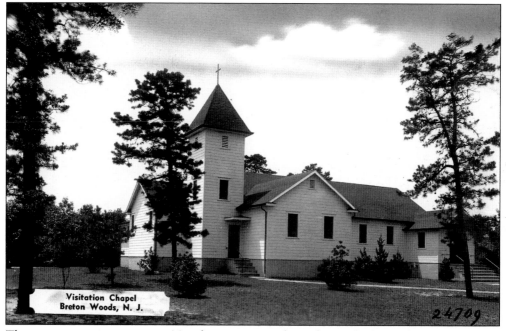

The numerous resort communities that sprang up along the south shore of the Metedeconk brought in many new religious and ethnic groups to Brick Township. The Roman Catholic Church was the first to open a summer chapel when Visitation Chapel opened on Mantoloking Road in 1938.

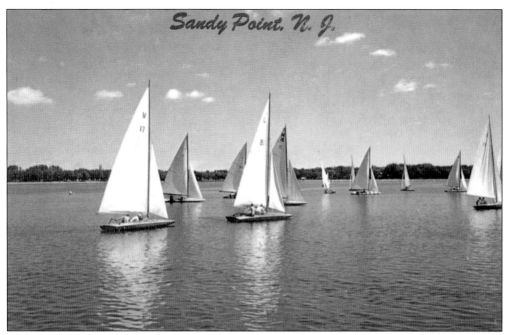

Established in 1947, Sandy Point is a lagoon community on the north side of Mantoloking Road. The lagoons open onto the Metedeconk River. There is a riverside beach and boat ramp managed by the Sandy Point Yacht Club in this area as well.

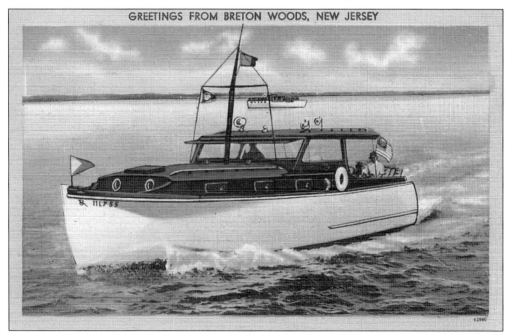

This "Greetings from Breton Woods" postcard shows a cabin cruiser, representing the 1940s through the 1960s, when Breton Woods was at its height of activity.

Three

METDECONK TO BRICK
1837–PRESENT

Postmarks Metedeconk, Burrsville, Laurelton, Brick Town, and Brick all served the same geographic section of Brick Township, only at different times. The one exception is Metedeconk II, which handled the mail for the eastern section of Princeton Avenue and the Beaver Dam Creek area for a period of 18 years. The original Metedeconk Post Office was established in 1837. In 1810, the Butcher/Burr Iron Forge became the main employer in town, and the village around the forge was called Burrsville. By 1884, the postmark had changed from Metedeconk to Burrsville, taking its name from the village. In early 1910, the biggest employer in the village was a chicken farm owned by the Park and Tilford Company. Mr. Park did not like shipping his chickens and eggs from a place called Burrsville, and he asked the local population to consider a new name. They did and selected Laurelton for all the laurel that grew in the area. Along with the new name came the new postmark of Laurelton. The postmarks Laurelton and Metedeconk II remained until the US Postal Service decided to consolidate all the village post offices into one, located on Princeton Avenue, and use the postmark of Brick Town. In 1978, two members of the Brick Township Historical Society decided it was time to correct the misnomer "Brick Town," as people began to accept this as the name of the town. After many months and with the help of the local congressman, Edwin Forsythe, the US Postal Service agreed to use the name "Brick," which is the present postmark.

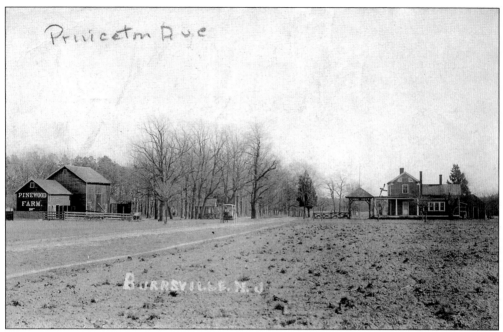

Johnson's Pinewood Farm was located in the village of Burrsville on both sides of the road to Parker's Neck, presently Princeton Avenue. Because of the number of Johnson families living in this area, it was commonly referred to as Johnsonville. (Courtesy of Walter Durrua.)

Joseph W. Brick, for whom Brick Township is named, established Bergen Iron Works in 1833. The millpond known as Lake Carasaljo was named for Brick's three daughters: Caroline, Sarah, and Josephine.

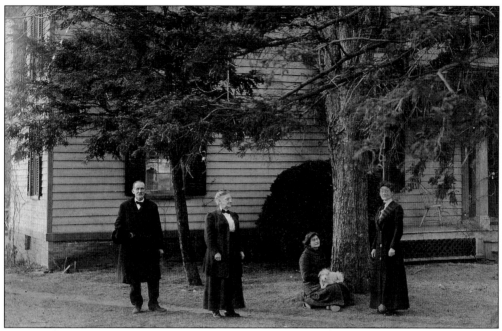

Standing in front of their home in Burrsville are, from left to right, Horatio Ely Havens, his wife, Lydia, and their daughter Emma Havens Young. Mary Young, the daughter of Emma Havens Young, sits beside the tree. (Courtesy of Walter Durrua.)

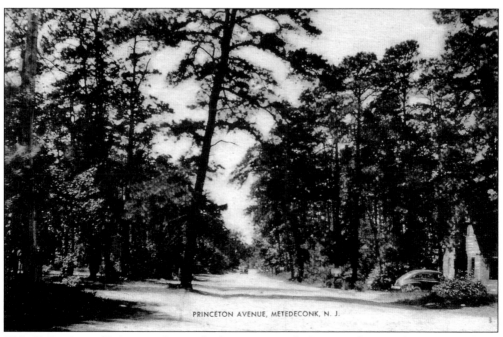

PRINCETON AVENUE, METEDECONK, N. J.

This 1940s view of Princeton Avenue looks west towards the area where Midstreams Road and Princeton Avenue come together. The area, known as Metedeconk, had its own post office.

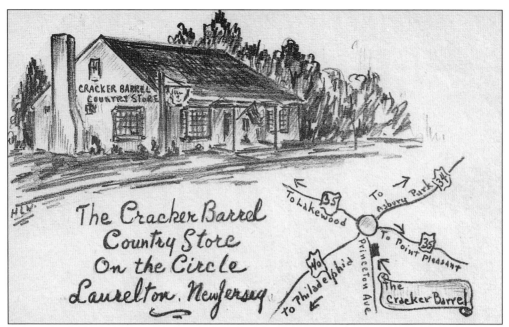

The very popular Cracker Barrel Country Store, located on Princeton Avenue in the village of Laurelton, was run by Leland Downey. The Cracker Barrel carried everything one might find in a hardware store, plus everyday grocery needs, greeting cards, stationery, photograph services, Western Union, and notary services.

Known as the road to Lakewood or the road to Point Pleasant, depending upon the way a person was traveling, this was later called Route 35, then Route 88 East and West. It was the first gravel road constructed in Ocean County and the first concrete-paved road constructed in Ocean County.

50

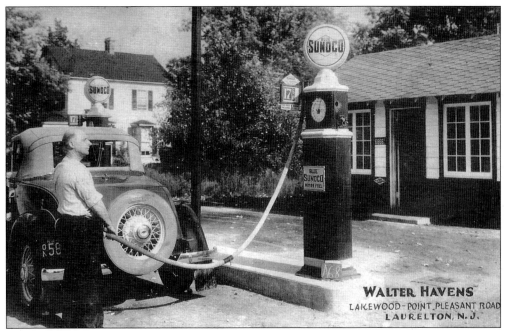

One of Brick's earliest gas stations was opened by Walter Havens and his son-in-law Ray Durrua. Their Sunoco service station was located on the south side of Highway 35, later renumbered as Highway 88, a short distance from the intersection of Highway 34 (Route 70). According to this 1930s postcard, gasoline was selling for 17¢ per gallon.

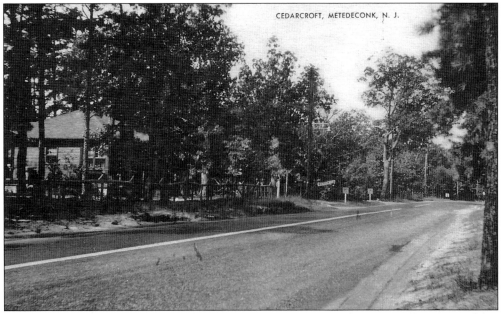

Pine Shores Corporation had purchased several tracts of land from the Havens family in 1936. By 1938, it had filed a plot plan to develop the community of Cedarcroft. Cedarcroft, located on both sides of Princeton Avenue, started out as a summer resort community; the corporation named the streets after Native American nations. The Cedarcroft logo was a Native American in headdress with the slogan "Where the Forest Meets the Shore."

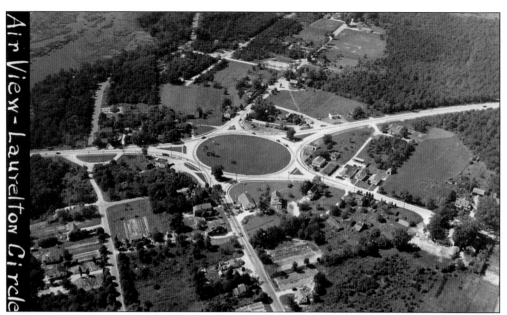

In 1937, in order to put people to work and correct a problem curve in the road known locally as Dead Man's Curve, the Works Progress Administration constructed the Laurelton Traffic Circle. Several homes had to be moved and others demolished, changing the small village of Laurelton forever. The traffic circle remained in use until a new intersection was constructed in 1987.

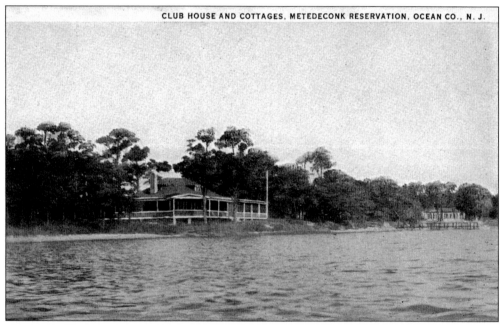

CLUB HOUSE AND COTTAGES, METEDECONK RESERVATION, OCEAN CO., N. J.

Theodore and Dalia Dickerson opened Metedeconk Bathing Beach Club on the north shore of the Metedeconk River. The club was open from Memorial Day to Labor Day and charged an admission of 25¢ per carload. The club continued to operate into the 1970s, when a decline in business was brought about by river pollution. In 1985, the land was sold to a developer who built private homes there.

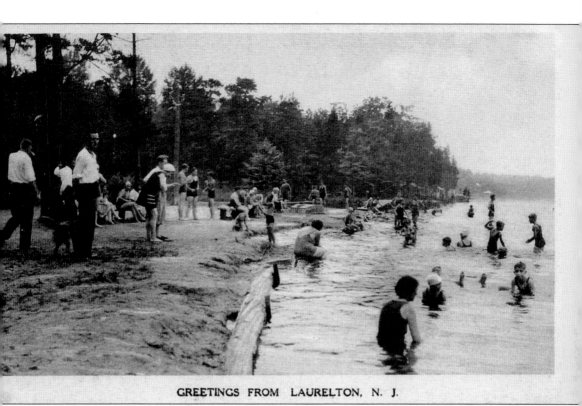

GREETINGS FROM LAURELTON, N. J.

There were other beaches along the north shore of the Metedeconk River. Some were run for profit, and others were the remains of abandoned summer camps local people took over and used as their own.

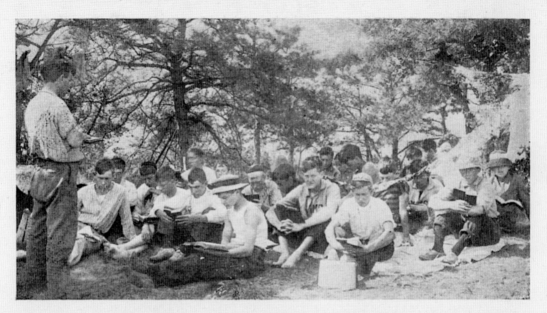

BIBLE CLASS, CAMP METEDECONK, BAY HEAD, N. J.

Named for the river on which it was located, Camp Metedeconk was organized in 1902 and operated until 1918. In 1908, Branson Lepley purchased the 15-acre camp and turned over the operation to his widowed daughter Maude Dryden to run for additional income.

Camp Metedeconk

BAY HEAD, N. J.

RETURNING FROM A SAIL

Along with sailing lessons at Camp Metedeconk, the boys learned navigation, lifesaving, and craft skills and played strategy games like chess. There was also free time during which the campers could take part in any personal interest.

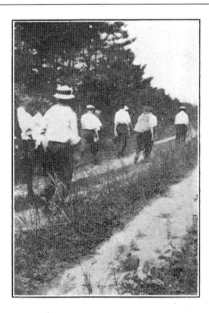

Camp Metedeconk

BAY HEAD, N. J.

OFF FOR A TRAMP

Physical fitness was combined with nature studies in the postcard captioned with "Off For A Tramp." Note on the postcard the name Bay Head. Many camps used a Bay Head address. Some used the designation because the camp owners lived in Bay Head or because they believed Bay Head was more prestigious. It was also used because few people recognized or knew where Brick Township was located.

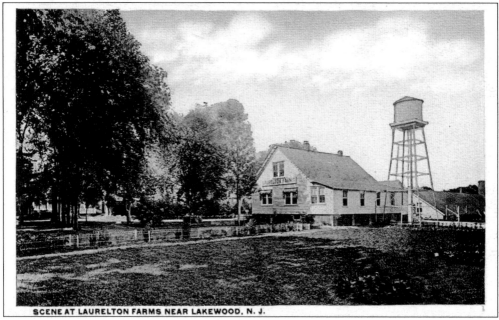

SCENE AT LAURELTON FARMS NEAR LAKEWOOD, N. J.

Austin G. Brown and J.T. Sideman established a chicken farm on property located on the road to Lakewood in 1901. They were suppliers of eggs and chicken to the Park and Tilford stores in New York City. Brown and Sideman had constructed a cooling room, wind–powered water pump, and water tank. The Brown Sideman Farm was capable of incubating 48,000 eggs at one time.

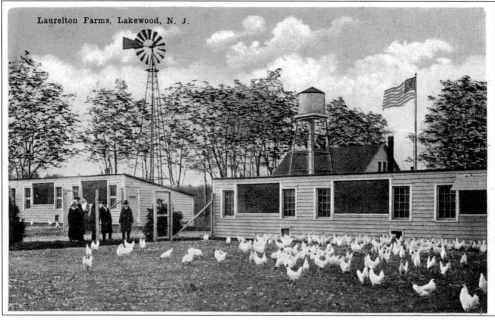

Laurelton Farms, Lakewood, N. J.

By 1909, the Brown Sideman Farm was said to be the world's largest supplier of a single breed with 35,000 single comb white leghorn chickens. Many residents came to be dependent upon the farm, either supplying feed, working as teamsters or constructing henhouses, or doing general custodial work as contractors.

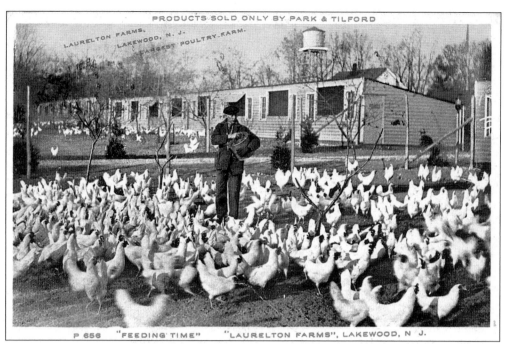

P 656 "FEEDING TIME" "LAURELTON FARMS", LAKEWOOD, N J.

Mr. Park did not like having his eggs and chickens shipped from a place called Burrsville, and in 1910, he asked the locals to change the name of the village. The local population, mostly employed at the chicken farm, decided to call the village Laurelton because of the abundance of laurel growing in the area, so the farm became known as Laurelton Farms.

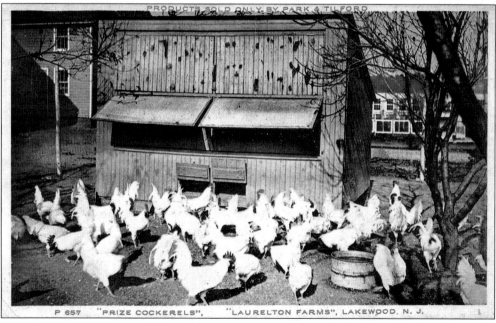

P 657 "PRIZE COCKERELS", "LAURELTON FARMS", LAKEWOOD, N. J.

Over the years, the farm grew in size, covering both sides of the road to Lakewood (Route 88 West). By present-day description, it stretches from Allaire Road (at the Hess gas station) to Jack Martin Boulevard.

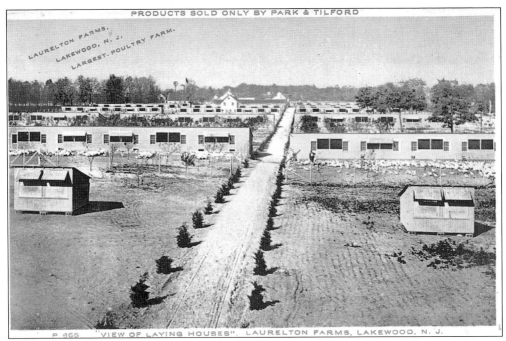

LAURELTON FARMS, LAKEWOOD, N. J. LARGEST POULTRY FARM.

P 465 "VIEW OF LAYING HOUSES", LAURELTON FARMS, LAKEWOOD, N. J.

In 1930, Laurelton Farms was sold at a sheriff's sale and purchased by Samuel Kaufman, a proprietor of a feed company in Toms River. Kaufman initially rented out the farm, but that didn't work out, so he subdivided the old farm into smaller farms. Kaufman then sold the smaller farms to his Jewish relatives and friends from New York. This introduced a new religious group to Brick Township.

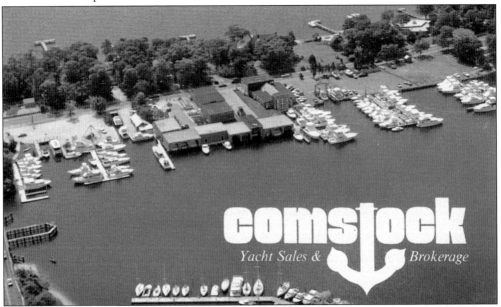

Located on Beaver Dam Creek at Princeton Avenue, Comstock's Yacht Sales and Marina has been in business since the 1940s. Established by Bucky Comstock, the marina was purchased by the Gahr family in 1973. They continue to operate the marina under the name of Comstock's Yacht Sales. (Courtesy of Kevin Hughes.)

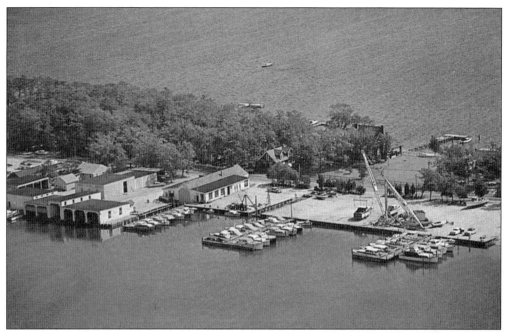

In 1985, the Gahr family expanded Comstock's Yacht Sales by purchasing the adjacent Dayton Trubee Yacht Brokerage Marina.

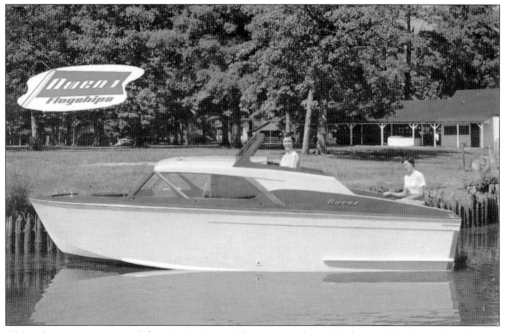

This advertising postcard for Lewis Boat Sales, situated on Highway 70, shows the Owens Flagship line of cabin cruisers. Owens Boat Company began building boats in the 1930s and continued into the 1970s.

This postcard shows that docks and bulkheads had not yet been built at Paradise Harbor, located on the north branch of the Metedeconk River and on the east side of State Highway 70.

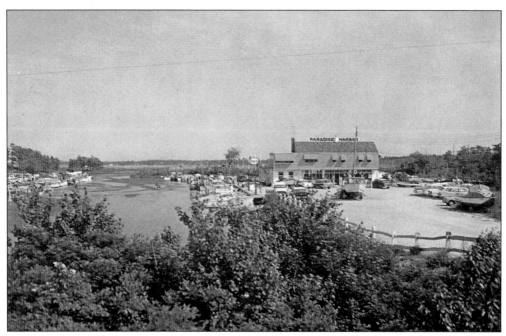

For many years, this section along Route 70 East has been the ideal location for marinas. Paradise Harbor Marina, also known as Paradise Craftsman Boat Builders, was located on Route 70 East. This is the current site for the family-run Brennan Boat Company and Marina.

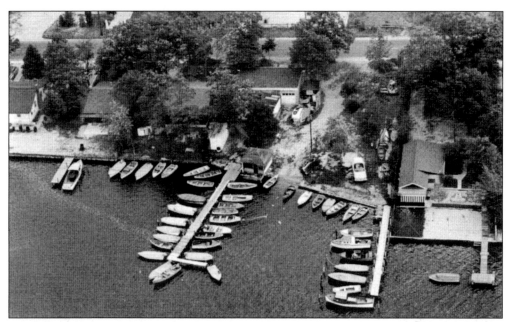

Sherman and Son is in the same location on Princeton Avenue where it was established by Robert K. Sherman Sr. in 1926. Now run by the third generation of the Sherman family, it is known as Sherman's Boat Basin, with the slogan "Experience with the honesty and integrity you deserve."

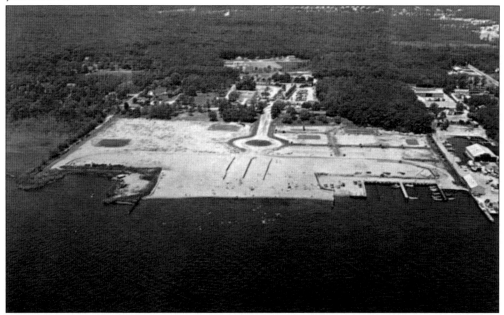

When Brick Township was created in 1850, the property that would become Windward Beach was owned by William S. Johnson, a member of the first Brick Township Committee. The property remained in the Johnson family until 1945, when Martin and Gesine Thomforde purchased the property. The Thomfordes converted the former farmland into a beach resort. Thomforde's Windward Beach Resort lay vacant for a few years before Brick Township purchased it in 1974.

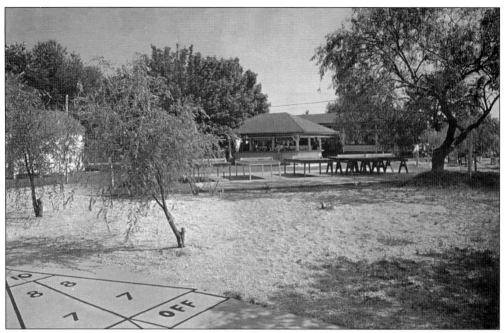

Thomforde's Windward Beach provided the opportunity for a variety of activities besides swimming and sun bathing. In the background is a gazebo where bands played and dances took place. There was a snack bar, shuffleboard, and tennis courts. In addition, there were changing rooms and bungalows for rent.

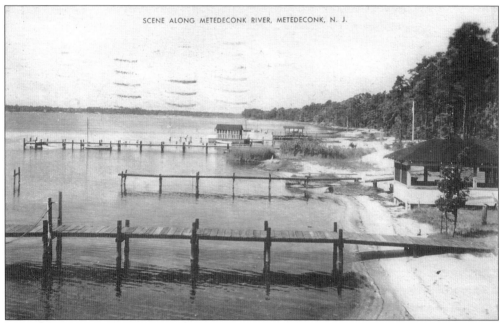

The typical docks along the Metedeconk River in the 1950s used cedar poles sunk into the mud with water pressure. A deck was built on top of the poles. Each winter, when the river froze over, the ice pulled the poles out of the mud, and in the spring, they were put down again.

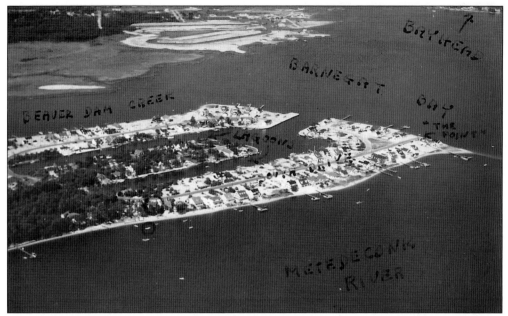

The original map, filed in 1923 by the Metedeconk Company, laid out lots for a mile and a half of Princeton Avenue on Wardell's Neck. Wardell's Neck was the east end of Princeton Avenue. At that time, there were no North and South Drives, nor lagoons.

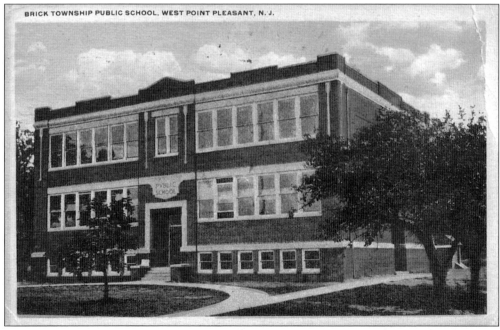

The original six-room Ocean Road School opened in 1900. The building was destroyed by a fire in 1915 and replaced by the structure in this postcard. It was then replaced in 2000 with a new Ocean Road School. The Ocean Road Schools were in West Point Pleasant, a section of Brick Township until 1920, when it became the Borough of Point Pleasant.

The Greenville Methodist Church, on County Line Road/Lanes Mill Road, was the only Methodist church for the people of Brick Township until the Herbertsville Methodist Church was built.

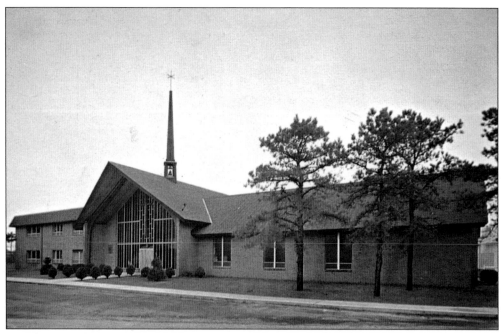

St. Thomas Christian Academy, a private coed school for prekindergarten through eighth grade, is located at St. Thomas Lutheran Church at 135 Salmon Street.

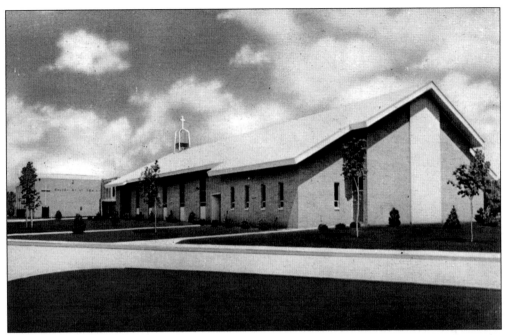

As the population increased in Brick Township in the 1950s and 1960s, there was need for another Catholic church. In 1962, St. Dominic's Roman Catholic Church was established, holding its first mass in the Route 88 Bowling Lanes. By 1965, a church building was being constructed on Van Zile and Old Squan Roads.

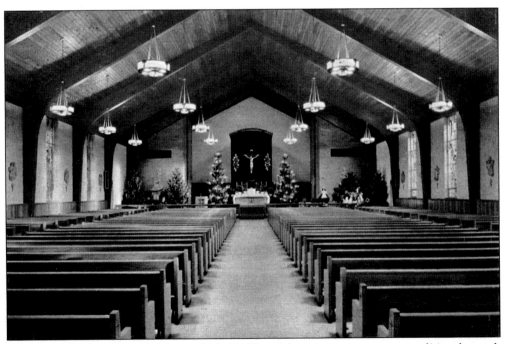

The interior of St. Dominic's Roman Catholic Church has a contemporary yet traditional appeal. St. Dominic's runs a prekindergarten-through-eighth-grade school adjacent to the church.

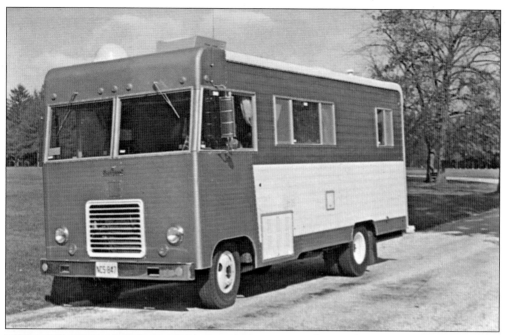

Motor homes first appeared in the United States during the 1920s. The MECO Company on Route 88 West promoted its sales, service, and rental of motor homes with this postcard.

This is an advertising postcard for Anchor Concrete Products, located at 975 Burnt Tavern Road. Anchor Concrete Products, a concrete manufacturing and distributing company, has been at this Burnt Tavern Road location since the 1960s.

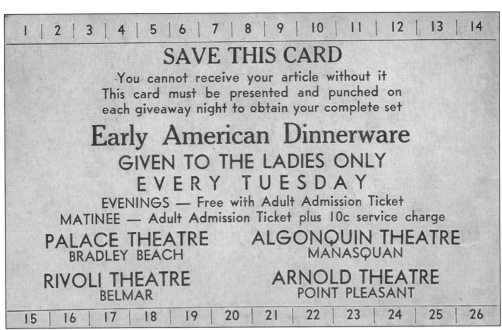

| 1 | 2 | 3 | 4 | 5 | 6 | 7 | 8 | 9 | 10 | 11 | 12 | 13 | 14 |

SAVE THIS CARD

You cannot receive your article without it
This card must be presented and punched on
each giveaway night to obtain your complete set

Early American Dinnerware

GIVEN TO THE LADIES ONLY
E V E R Y T U E S D A Y

EVENINGS — Free with Adult Admission Ticket
MATINEE — Adult Admission Ticket plus 10c service charge

PALACE THEATRE	ALGONQUIN THEATRE
BRADLEY BEACH	MANASQUAN
RIVOLI THEATRE	ARNOLD THEATRE
BELMAR	POINT PLEASANT

| 15 | 16 | 17 | 18 | 19 | 20 | 21 | 22 | 23 | 24 | 25 | 26 |

There were no movie theaters in Brick Township in 1950. Bricktonians had to go to Point Pleasant, Manasquan, Belmar, Bradley Beach, or Lakewood to see a movie. Movies would run a special Tuesday-night dish giveaway, which attracted many women from Brick. (Courtesy of Brick Township Historical Society.)

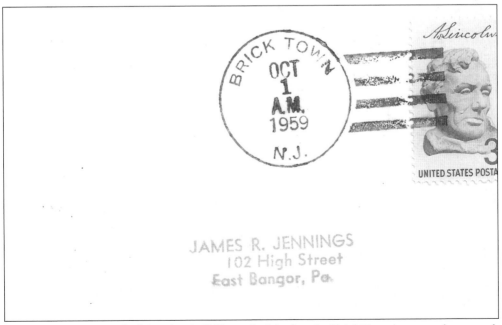

This envelope, postmarked October 1, 1959, marked the first day Brick Town's postmark was used. All the local village post offices were consolidated into one post office on Princeton Avenue.

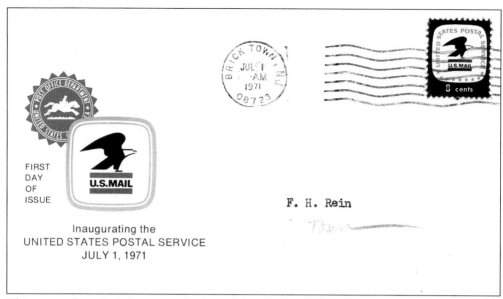

Inaugurating the
UNITED STATES POSTAL SERVICE
JULY 1, 1971

F. H. Rein

This postcard marked the reorganization of the US Post Office Department. Under the Postal Reorganization Act of July 1, 1971, the postal system was now called the US Postal Service, and the postmaster general was removed from the president's cabinet.

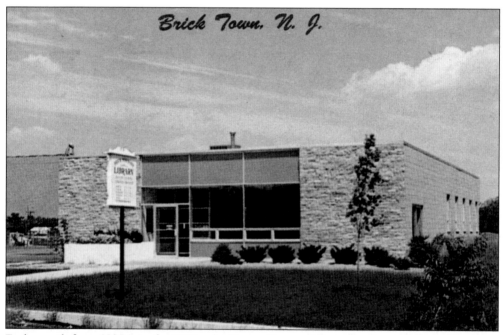

Brick Town. N. J.

Each month from 1925 into the 1960s, the Ocean County Library book car delivered books to private homes, serving as a mobile library station for local residents to check out books. In 1960, the Friends of Brick Township Library was formed, headed by Irene Alznauer, with the goal of establishing Brick Township Library. On April 5, 1965, a library opened on township property on Cedar Bridge Avenue next to town hall. This building served the public until 1976, when a new town hall housing the library was built.

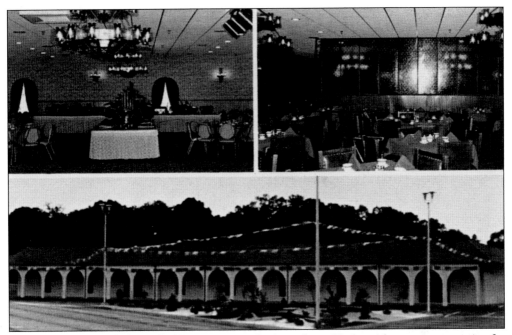

El Greco Restaurant opened in July 1972 on the Laurelton Circle with a seating capacity for 350 people. The restaurant had a cocktail lounge and banquet facilities. Following El Greco, the building was converted into three movie theaters; it then became office space and is now IHOP Restaurant.

This is an advertisement for custom-built homes by E.E. Van Schoick and Sons, Inc., at Brick Lake. Once part of Alonzo Van Note's cranberry field, Brick Lake Park, situated on the south side of Cedarbridge Avenue, was first planned in October 1953.

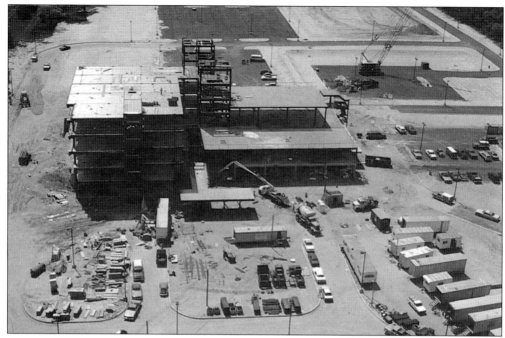

First conceived in 1961, Brick Hospital opened on July 4, 1984. The hospital's website (www.oceanmedicalcenter.com) reports, "In the decades since its inception, the hospital name has been changed from Brick Hospital, to The Medical Center of Ocean County (MCOC), to its current name Ocean Medical Center."

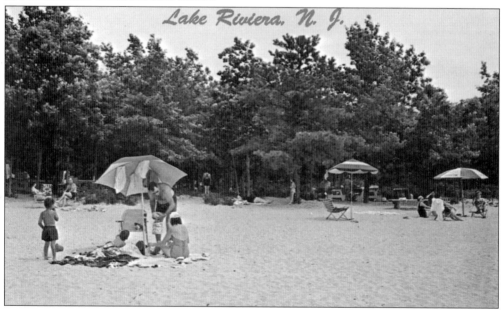

Developed in the 1950s as a summer resort, Lake Riviera was the work of brothers Ted and Ben Smith, who purchased 800 acres for this development. A second lake was developed, and on March 1, 1954, lots went on sale. Since this was a resort community, there was a clubhouse offering access to a lakeside swimming beach, Olympic-size pool, two tennis courts, and two basketball courts for a membership fee of $20 a year.

Four

CHADWICK TO NORMANDY BEACH
1882–PRESENT

On the peninsula, the area bordered on the west by Barnegat Bay and on the east by the Atlantic Ocean, the popular hunting and fishing community of Chadwick developed. In the 1880s, a railroad station and post office opened at Chadwick when the Pennsylvania Railroad connected with the New York & Long Branch Railroad, bringing passengers and mail to the peninsula area. The Chadwick Post Office in Dover Township (now Toms River Township) served the small number of residents just to the north in Brick Township.

In 1916, the Normandy Beach Realty Company purchased land on the peninsula and mapped out a proposed development called Normandy Beach. Normandy Beach Realty Company went bankrupt, and Coast and Inland Development Company took over development of Normandy Beach. By 1929, there were enough residents to establish a post office there. Ralph A. Helmuth served as the first postmaster.

A few of the later summer developments built on the peninsula area of Brick Township using either the Mantoloking address or the Normandy Beach address include Mantoloking Dunes, South Mantoloking, and Mantoloking Heights.

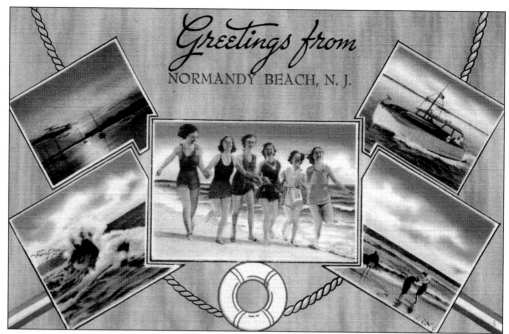

When referring to the area of Brick Township that lies between the Atlantic Ocean and Barnegat Bay, some call it a barrier island, while others call it a peninsula. It was this area straddling the boundary between Brick Township and then Dover Township that the Normandy Beach Realty Company selected in 1916 to locate the resort community of Normandy Beach.

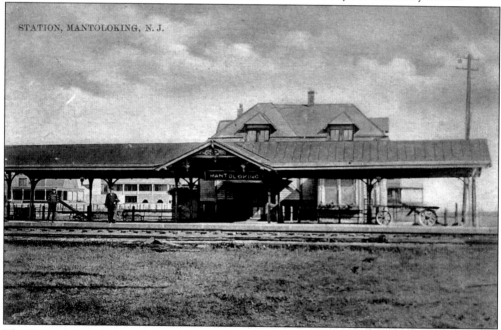

The Pennsylvania Railroad traveled from northern New Jersey down the peninsula area with stops at the resorts of Mantoloking and Chadwick. Summer resort developers found this a great way to get prospective buyers and provided free transportation from the railroad stations to their sales offices in communities like Breton Woods, Eagle Point, and Normandy Beach.

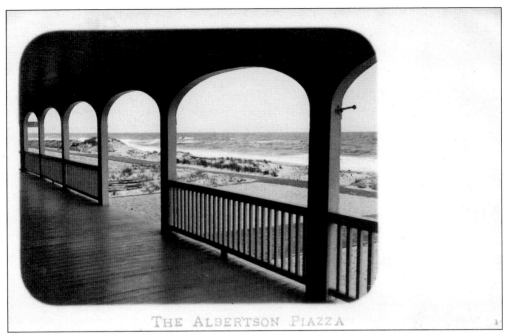

THE ALBERTSON PIAZZA

Many of the operators of summer camps in Brick Township were not local residents, so they took up summer residence in the hotels in Mantoloking. One of the hotels was the Albertson, where guests could sit and view the Atlantic Ocean from the piazza.

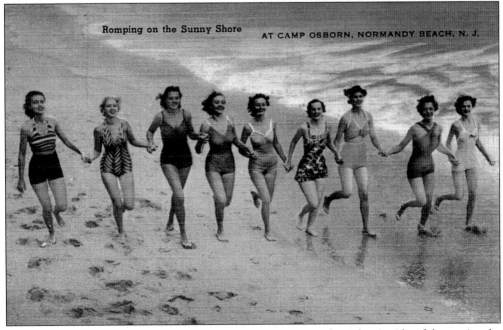

Romping on the Sunny Shore AT CAMP OSBORN, NORMANDY BEACH, N. J.

At Normandy Beach, most of the early development was on the Atlantic side of the peninsula. The beach was the big attraction, and the Barnegat Bay area, made up of marshland, was developed later.

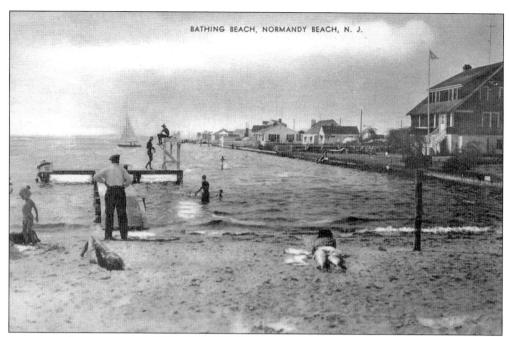

By 1921, the Normandy Beach Realty Company had gone bankrupt, leaving the few residents questioning what would happen to their purchases. Eventually, the Coast and Inland Development Company took over Normandy Beach with a new plan.

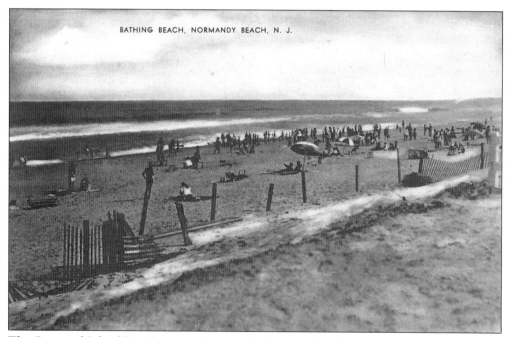

The Coast and Inland Development Company had a new plan for Normandy Beach that called for dredging the bay side, creating lagoons, and using the spoils to fill in the marshlands. The new plan included gravel streets, cement sidewalks, curbing, and electricity.

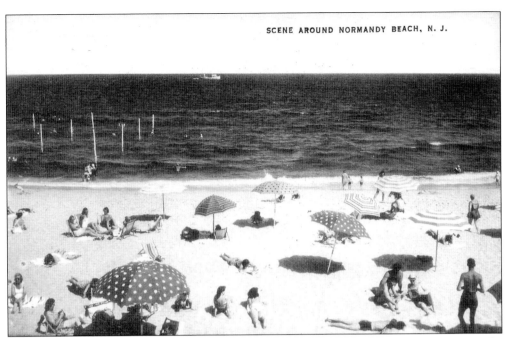

At Normandy Beach, as well as most bathing beaches, poles with ropes, as seen here in the upper left of the image, were set out in the ocean to mark the safe swimming areas.

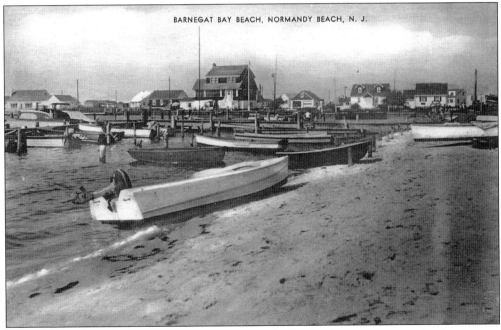

BARNEGAT BAY BEACH, NORMANDY BEACH, N. J.

With bay-side development under way at Normandy Beach, there was now a growing interest in boating. At first, most of the boats were small rowboats that could be beached. In 1929, the Normandy Club was organized to oversee recreation and entertainment.

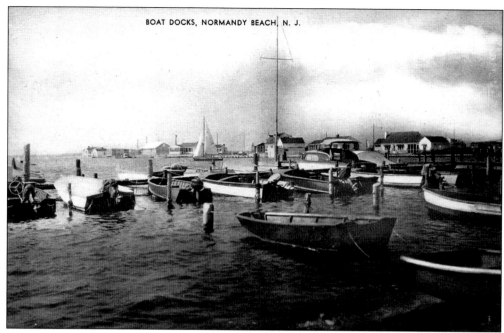

The Normandy Club rented space in the old railroad station that the Coast and Inland Development Company had moved near the bay. The club built docks and ran other activities for the members.

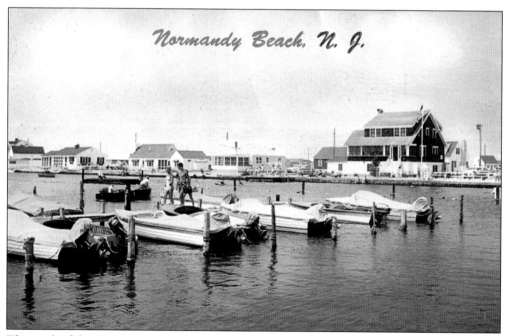

The work of the Coast and Inland Development Company can be seen in the additional homes in the background of this postcard. Unfortunately, the 1930s was not kind to the Coast and Inland Development Company, and it too went bankrupt.

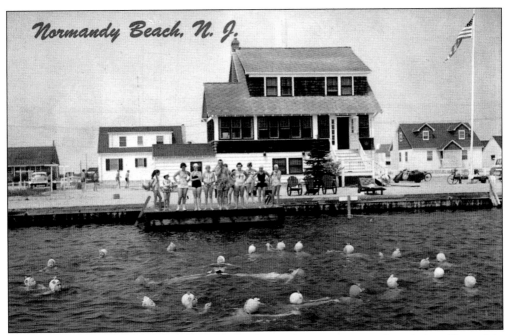

The Normandy Club, and later the Normandy Beach Improvement Association (formed in 1937), organized many activities, including a water ballet team that presented demonstrations in Normandy Harbor.

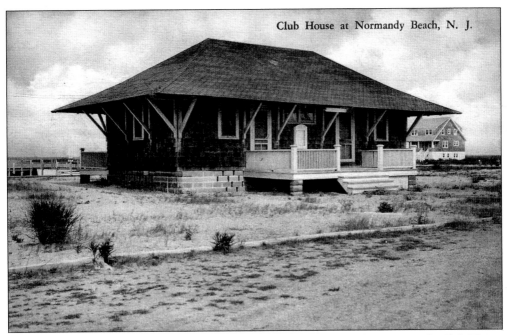

Normandy Beach is located in both Brick and Dover Townships. The Normandy Club House was located just across the border in Dover Township. In 1935, it served as the clubhouse for the Normandy Beach residents.

Brick Township Beach, N. J.

Along the peninsula of Brick Township are public- and association-owned beaches. All are protected by lifeguards certified for ocean and tidal water rescues. This postcard shows the surf launching of a lifeguard boat.

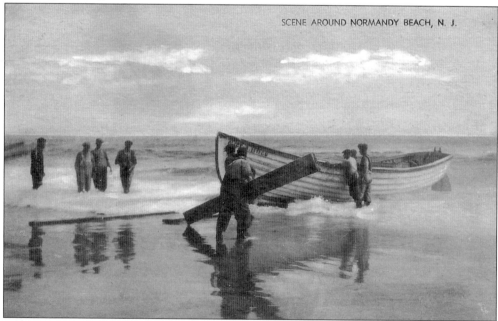

SCENE AROUND NORMANDY BEACH, N. J.

For years, commercial fishermen made their living from the peninsula area using the pound fishing method. Pound fishing required a fishing net strung out to sea perpendicular to the shore. At the sea end, a net box was built. In the spring, the box was on the south side, and when fish swam north, the net stopped their progress, forcing them to swim out to sea and get trapped in the boxes. In the fall, it worked in just the opposite way.

Along the sandy ocean shoreline of the peninsula are private beaches and homeowner association beaches, as well as three public beaches and a bay-side park owned by Brick Township.

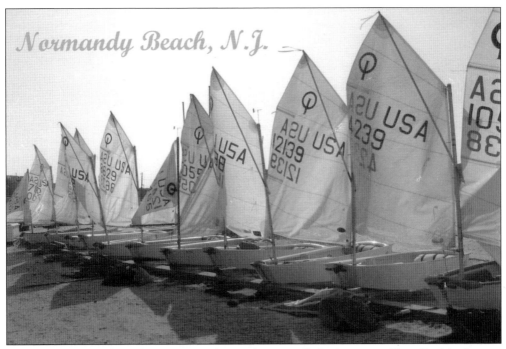

Lined up along the bay side at Normandy Beach are small single-crew sailing dinghies known as Optimists. The Optimist sailing competitions were very popular on the bay and were limited to children up to the age of 15.

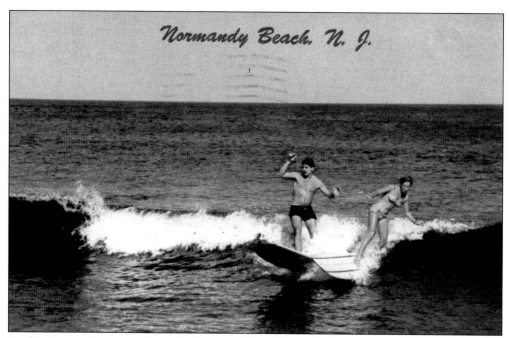

Normandy Beach, N. J.

Surfing is a popular sport along the beaches of Brick Township's peninsula area, as it is all along the coast of New Jersey.

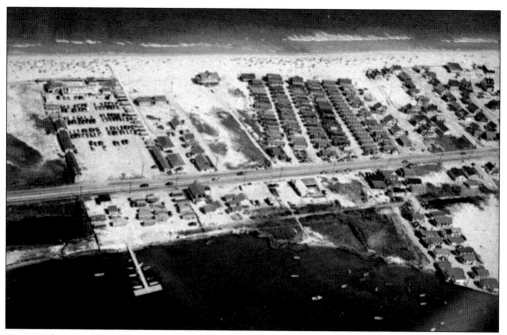

An aerial view from Barnegat Bay shows Sea Bay Park, Connie and Piela Cabins, Sullivan Cabins, and Camp Osborn. The 1913 highway running through the peninsula was called Ocean Road, then State Highway 37, and later State Highway 35 North.

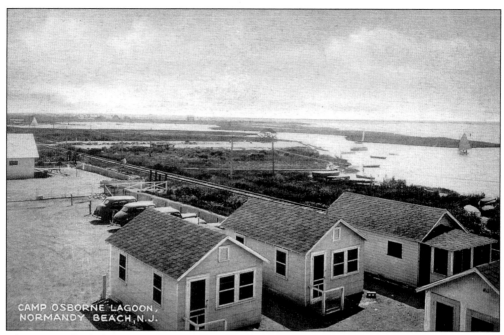

This postcard titled *Camp Osborn Lagoon, Normandy Beach, N.J.*, offers a view of the Pennsylvania Railroad tracks running down the peninsula and marshlands of Barnegat Bay. The railroad tracks are now State Highway 35 South.

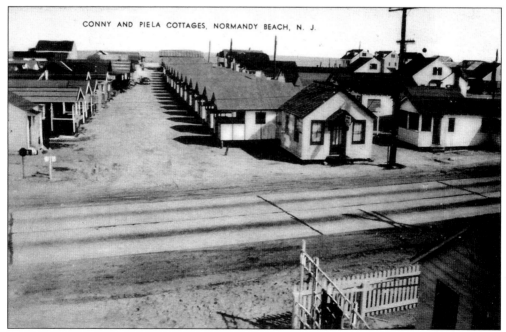

Cottages and cabins lined Ocean Road north of Normandy Beach. Some were privately owned, and others, like the Connie and Piela Cabins, were rented to vacationers. The building facing the road is the rental office.

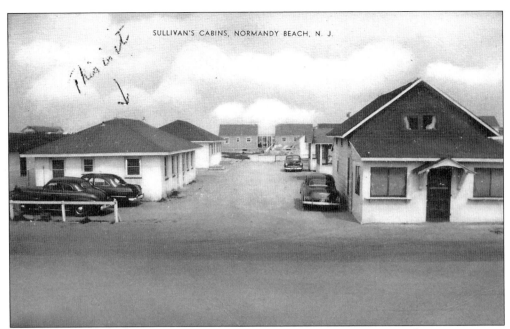

SULLIVAN'S CABINS, NORMANDY BEACH, N. J.

This late-1940s postcard shows another set of rental cabins belonging to the Sullivan family.

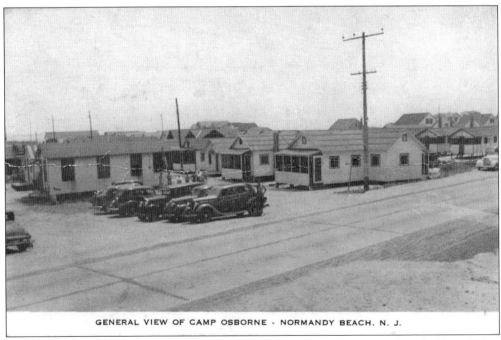

GENERAL VIEW OF CAMP OSBORNE - NORMANDY BEACH, N. J.

Camp Osborn is made up of five blocks of cabins. The title on this postcard reads *General View of Camp Osborne—Normandy Beach*. The use of Osborne with an "e" comes into question, as it should be spelled Osborn.

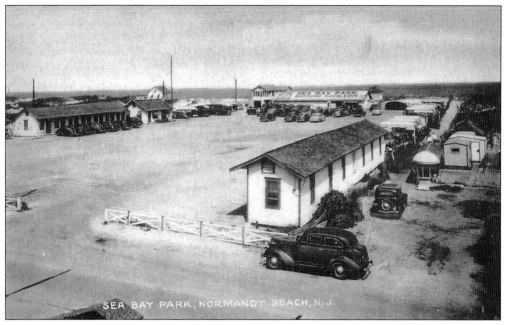

A resort for day-trippers, Sea Bay Park Bathing Pavilion stretched from the Atlantic Ocean to Barnegat Bay. There were lockers, showers, changing rooms, cabins for rent, and plenty of parking. This is now the site of Brick Township Beach III and Bayside Park.

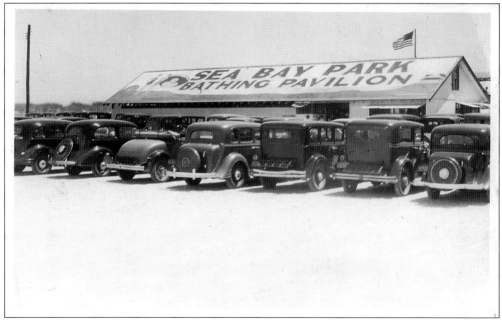

The parking lot at Sea Bay Park Bathing Pavilion filled with cars indicates the role the automobile played in American life during the 1930s.

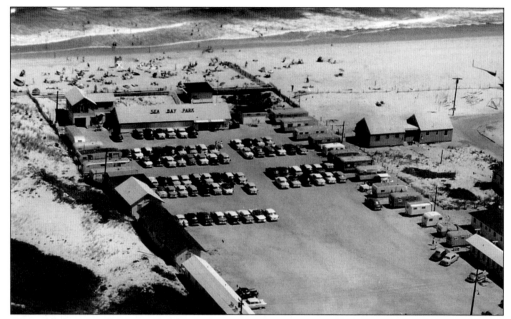

This aerial view of Sea Bay Park Pavilion shows the several buildings that made up the park. Along the right side of the parking lot in this 1950s postcard is a line of mobile trailers.

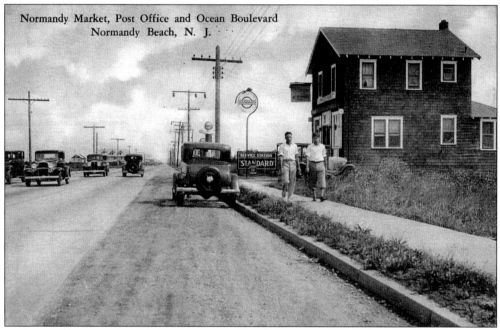

At the southern end of Normandy Beach in Brick Township, just north of the Dover Township line on the east side of the main road, is the Normandy Market. Besides being a food market, it was also a post office and Standard Oil gas station.

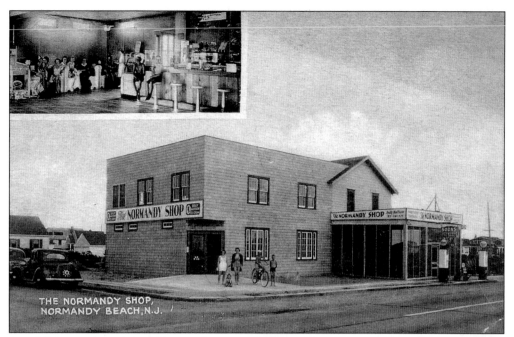

An addition to the original Normandy
Market housed an ice cream parlor
from the 1950s through 1970s.

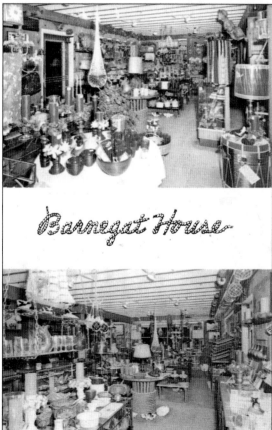

On the corner of Sixth Avenue and
Route 35, in the original Normandy
Market, was the Barnegat House,
pictured here in the 1970s. The gift
shop carried a large selection of nautical
and exclusive items and greeting cards.
It also advertised gift wrap and shipping
all over the world.

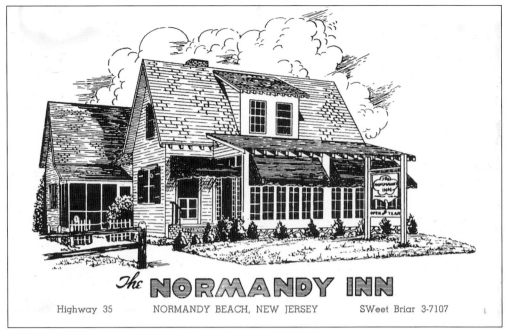

The Normandy Inn was located on State Highway 35 in Normandy Beach. Established in 1934 by Joseph and Jane Wheeler, the inn was open all year and served lunch and dinner weekly and Sunday dinner from 12:30 to 8:30 p.m.

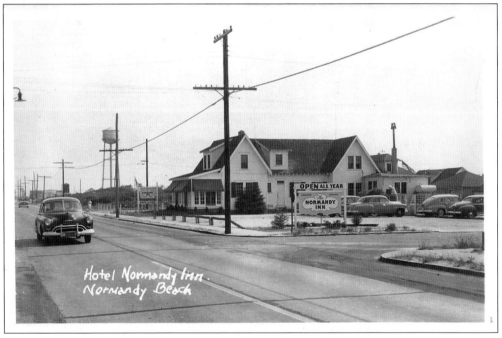

This is a 1940s roadside view of the Normandy Inn. Note the water tower in the background. The concrete road is the northbound lanes of State Highway 35.

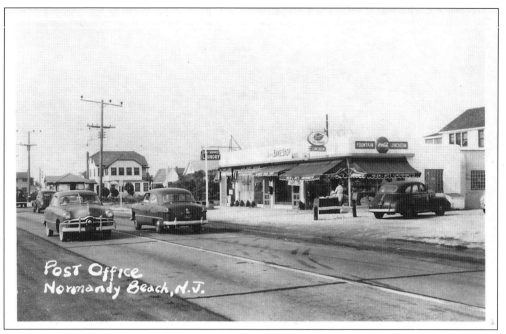

The Normandy Beach Post Office was established on October 10, 1929, with Ralph A. Helmuth as postmaster. The post office is located between the Bake Shop and Self Service Laundry.

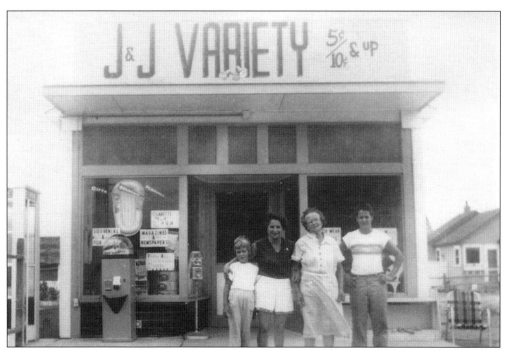

Located on Highway 35 North, J&J Variety Store was established in 1955. The store sells beach chairs, surfing mats, beach umbrellas, and the postcard seen here. Standing on the far right is John Szumaski, the present proprietor of the store, when he was 15 years old.

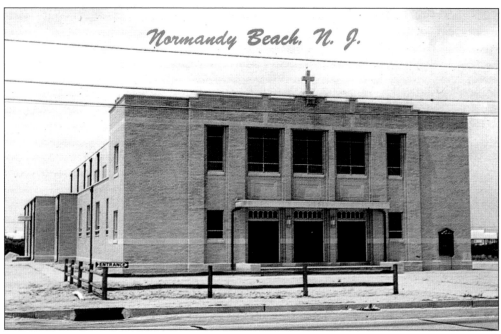

Our Lady Queen of Peace Roman Catholic Church on State Highway 35 North, built in 1953, is the only Catholic church in Normandy Beach, Brick Township. The church is now a summer church and part of the parish of St. Pio of Pietrelcina, Lavallette, New Jersey.

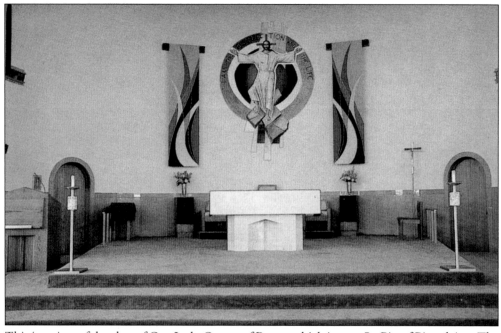

This is a view of the altar of Our Lady Queen of Peace, which is now St. Pio of Pietrelcina. The church is open from Memorial Day to Labor Day.

St. Joseph by the Sea, located at 400 State Highway 35 North, is a retreat house for the Religious Teachers Filippini. The facility includes a chapel, a conference room, a dining room that can accommodate 40 people, and a beautiful view of the ocean.

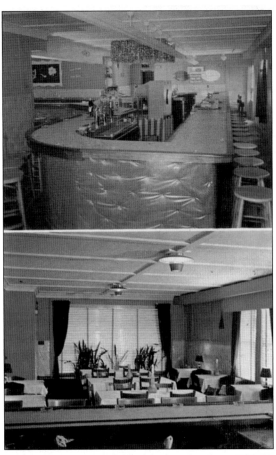

This two-part postcard shows the bar at Murphy's Sea-Bay Inn where Harold Murphy led his nightly sing-alongs. The bottom half shows the dining area as viewed from behind the bar.

Called the Shamrock Room, this is the banquet, wedding party, and meeting room at Murphy's Sea-Bay Inn.

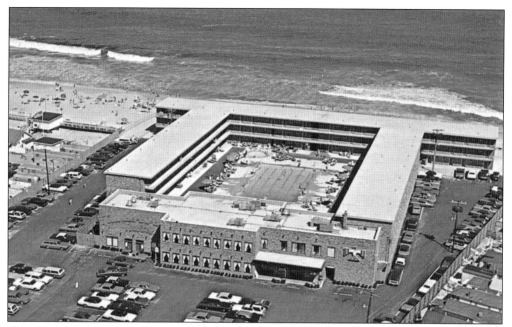

The Thunderbird Resort Motel was located on State Highway 35 by the Atlantic Ocean. The motel contained 140 rooms with 400 feet of private beach on the Atlantic Ocean. There was a dining room, coffee shop, the T-Bird Lounge, and sauna. All rooms had heat, air-conditioning, and outside views. Across from the hotel was a bay-front park for boating and fishing.

This postcard advertises the T-Bird Lounge, guest rooms, and dining room at the Thunderbird Resort Motel. Open all year, the Thunderbird hosted a New Year's gala with dinner, dancing with two bands, and the Fabulous T-Bird Buffet Brunch the following day. It also ran a winter special with a choice of shrimp marinara, cheese lasagna, London broil with garlic bread, dessert, and coffee for $3.65.

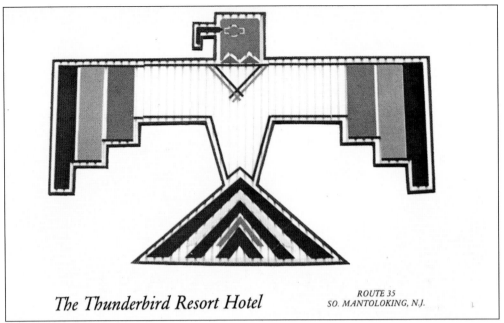

The Thunderbird Resort Hotel

ROUTE 35
SO. MANTOLOKING, N.J.

Standing above anything else on the peninsula area was a sign across State Highway 35 from the Thunderbird Resort Motel, approximately 30 feet high by 20 feet wide, advertising the motel with the Thunderbird symbol.

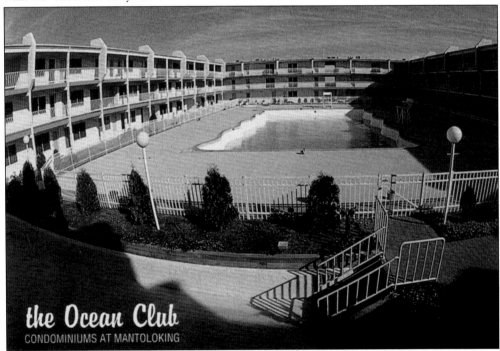

The Ocean Club Condominiums replaced the Thunderbird Resort Motel. The individually owned condominiums included studio, one-bedroom, and two-bedroom apartments. There is an Olympic-size swimming pool, kiddie pool, private ocean beach, community game room, and parking. A sales and rental office is on site.

Five

POINT PLEASANT
TO HERBERTSVILLE
1834–1938

In the northeast section of Brick Township was the rural village of Herbertsville, where the mail delivery came through Lower Squankum in Howell Township and later through the village of Point Pleasant in Brick Township. In 1884, a post office was established with James Mitchell as postmaster, and mail continued to come through Point Pleasant. Once a week, mail was picked up in Point Pleasant and brought back to the Herbertsville Post Office, and the local residents would pick up their mail. In the early 1900s, when Amy Lecompt and Ira Ivins were postmasters, Ben Herbert made the once-a-week mail run to Point Pleasant, and each time he went, he posted a sign offering residents rides to Point Pleasant for 15¢. From 1930 to 1934, Rue and Amy Gant served as postmasters in their general store.

On May 10, 1934, the Herbertsville Post Office closed, and it reopened on August 23, 1935, in Glossop's General Store. Daneil Glossop was the final Herbertsville postmaster before mail delivery returned to Point Pleasant.

Located on the east side of Herbertsville Road, Sidney Herbert's general store was built in the mid–1800s and served the community of Herbertsville for almost 100 years. Sidney was a local businessman and politician, having served on the township committee. The Glossop family operated the store with Daniel Glossop as postmaster in 1934. The building was eventually converted to a four-family house. (Courtesy of Brick Township Historical Society.)

This house, built by Tommy Havens in the mid–1800s, once stood where the present Herbertsville firehouse is on Herbertsville Road. The store, a later addition, was run by the Tiltons, followed by the Gant family. Rue and Jane Gant served as postmasters from 1927 to 1934. (Courtesy of Barry and Margaret Osborn.)

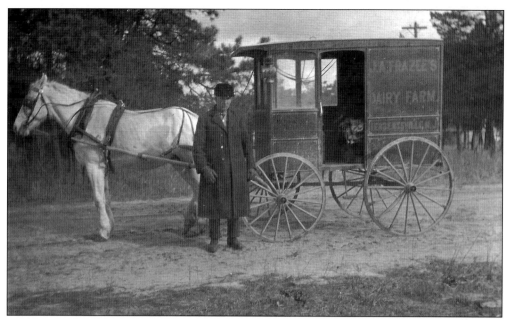

James Frazee grew a variety of vegetables and managed a dairy herd on his farm on Herbertsville Road. Pictured in this postcard is James Frazee with his dairy wagon. Frazee's farm later became Bill's Horse Ranch and, even later, a condominium development.

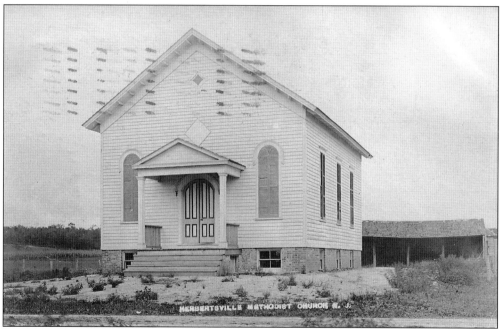

Built in 1876, the Herbertsville Methodist/Episcopal Church stands on the corner of Herbertsville and Thiele Roads. When originally built, the church had no basement, indicating that this postcard photograph was taken after 1900. The building is now a church hall for Epiphany Roman Catholic Church on Thiele Road. (Courtesy of Barry and Margaret Osborn.)

This 1948 postcard intended to rescind an agreement to build a new school in Herbertsville and instead spend the money on an addition to the Osbornville School. Parents of the Herbertsville children who were attending first through eighth grades in a two-room 1858 school with no running water loudly protested. In September 1949, the four-room Herbertsville School on Lanes Mill Road opened, as did a new addition to the Osbornville School.

Stanley R. Osborn's Field Farms was a chicken farm located on the corners of Herbertsville and Sally Ike Roads where Mayo Estates is located today. Stanley employed many local women to collect, candle, and package the eggs.

Located in the village of Point Pleasant, the Pine Bluff Inn on the Manasquan River was the starting point for the adventures of two young girls in Augusta Huiell Seaman's 1919 children's novel *The Slipper Point Mystery*. This is the story that inspired the legend that a house in Brick Township was on the Underground Railroad.

Joe Wert's general store and Atlantic gasoline station on Herbertsville Road was taken over by Chevron Oil Company in 1965. In October 1965, Carmine Lepore took over operation of the service station. Over the years since, the station has carried several different brands of gasoline from Atlantic, Chevron, Gulf, Mobil, and Valero. The gas station is still in the Lepore family and is operated by the third generation of Lepores.

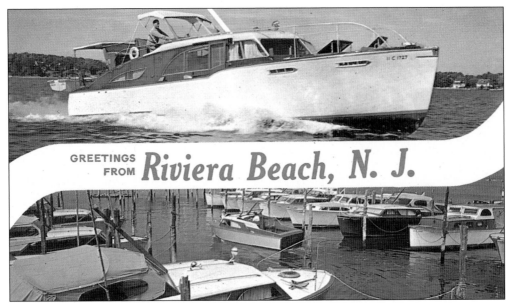

GREETINGS FROM *Riviera Beach, N. J.*

In 1927, Riviera on the Manasquan was rumored to be the largest land purchase in New Jersey. The plans called for a summer resort community with a clubhouse, entertainment area with swimming pool, docks for boats, and entertainment at Inspiration Island. By the 1930s, the clubhouse, called the Riviera Yacht Club, and several homes had been built before the Depression put Coast Finance Company out of business. (Courtesy of Kevin Hughes.)

GREETINGS FROM RIVIERA BEACH, N. J.

UNITED WE STAND

(C) 1941 Tichnor Bros., Inc.

This 1941 postcard in red, white, and blue was patriotic in meaning. After World War II, brothers Ted and Ben Smith took over the development of Riviera Beach. They arranged excursion trips from northern New Jersey, New York, and Philadelphia with the intent of signing sales contracts. They also promoted building Exit 91 from the Garden State Parkway to make it easier for prospective buyers to get to their developments.

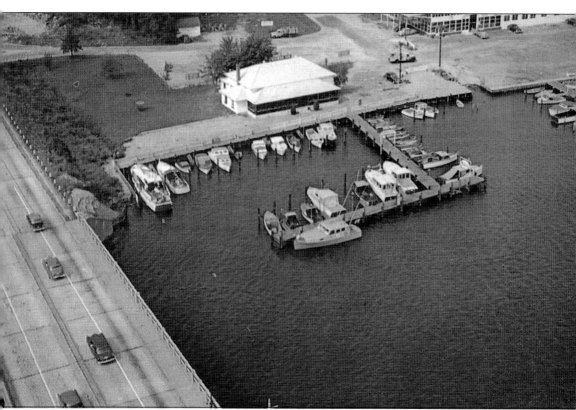

After the failure of Coast Finance Company, the Riviera Beach Yacht Club was converted into a restaurant called the Riviera Inn, operated by Bob and Evelyn Casperson.

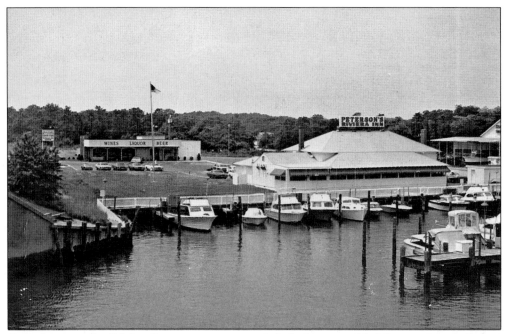

Over the years, the Riviera Inn restaurant expanded; docks were added for rentals and allowed patrons to drive their boats to the restaurant. Tragedy struck when fire broke out, partially destroying the restaurant. The newly rebuilt restaurant is larger. A liquor store was added, and the restaurant, run by the Peterson family, became known as Peterson's Riviera Inn.

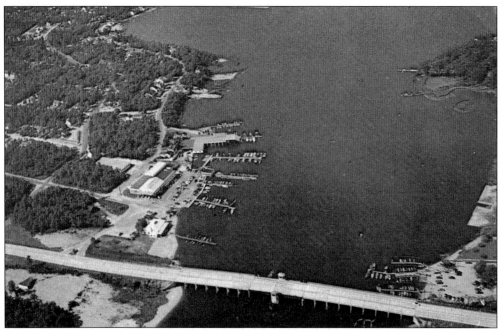

In this postcard, the view looks over State Highway 35 (Highway 70) Bridge and the Manasquan River. Peterson's Riviera Inn, Chapman's Boat Sales, and the Riviera Beach section of Brick Township are in the background, all on the south side of the river.

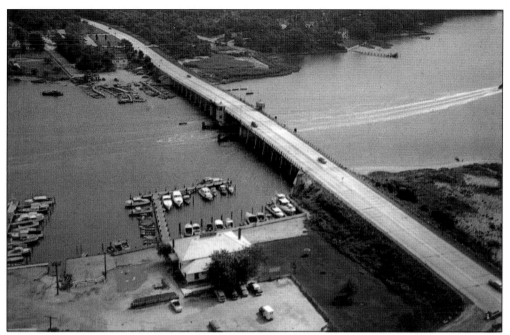

The Manasquan River Bridge connects Brick Township in the foreground with the Borough of Brielle in the background. At the bottom of the card is the Riviera Inn Restaurant and Marina, presently the River Rock Restaurant and Marina.

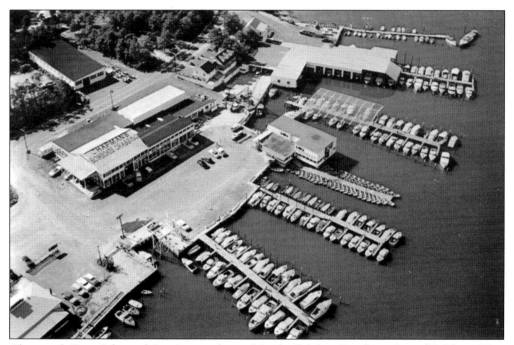

Chapman's Boat Sales and Service was located in the Riviera Beach section of Brick on First Avenue and the Manasquan River. Chapman's Boat Sales and Service, now Marine Max, had branches in Waretown, Manahawkin, and Punta Gorda, Florida.

This is an advertisement card for Chapman's Boat Sales and Service, which specialized in the sales of Jersey Sea Skiffs. Jersey Sea Skiffs were made by Luhrs of Morgan, New Jersey. Chapman's also sold Evinrude and Elto outboard motors and offered 65 rowboats for rent.

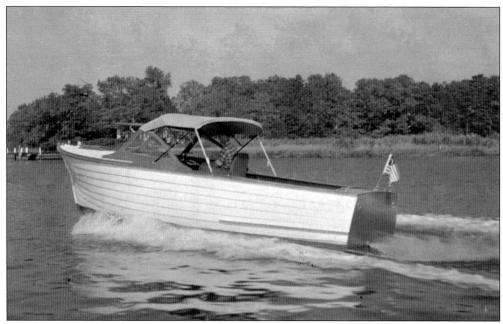

Luhrs of Morgan, New Jersey, established in 1930, was a well-known builder of lapstrake-hulled wood boats. Pictured here is Luhrs' popular 26-foot Jersey Sea Skiff, sold by Chapman's of Riviera Beach.

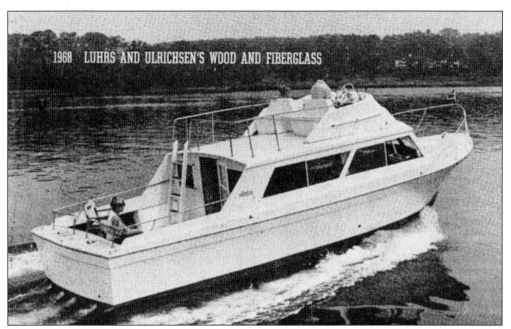

Though the wood boats were still being sold, Chapman's Boat Sales and Service had to keep up with new technologies in boating, and in the 1950s, the company added fiberglass boats by Ulrichsen and Silverton to its sales fleet. (Courtesy of Kevin Hughes.)

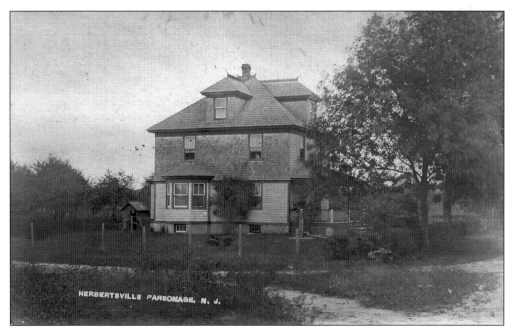

Built around 1890, this house stands on the corners of Herbertsville and Lanes Mill Roads. In 1910, the house was destroyed by fire and rebuilt using the same foundation and plans. The postcard calls it the parsonage; however, since 1910, it has been a private home.

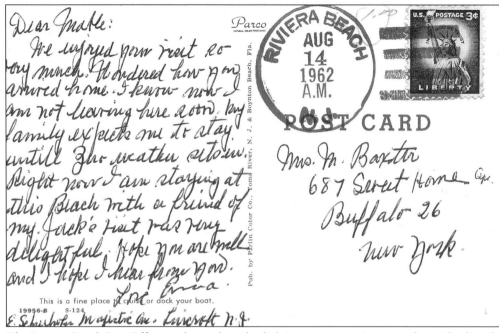

Pub. by Parlin Color Co., Toms River, N. J. & Boynton Beach, Fla.

The Riviera Beach Post Office was located in Charlie's Store on Main Avenue, where Charlie sold newspapers, groceries, and gasoline, as well as kerosene used in space heaters and oil lamps.

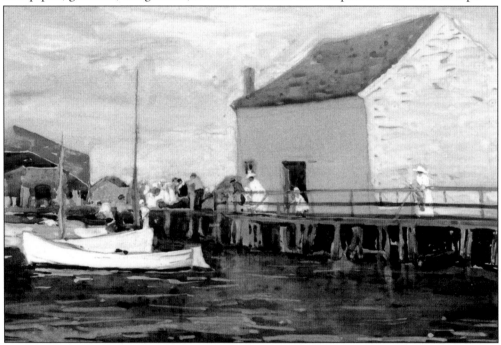

Pictured here is an untitled impressionist painting by Ida Wells Stroud, who came to Brick to live with her daughter Clara Stroud Colvin at her home on Gunning Club Road (currently Ridge Road). According to art dealer Roy Pedersen of Pedersen Galleries of Lambertville, Ida and Clara are the only known mother and daughter impressionist artists in the United States, and their paintings can be found in museums and art galleries all along the East Coast.

Six

OSBORNVILLE
1879–1960

Osbornville was located between the Metedeconk River on the north, Kettle Creek on the south, Barnegat Bay on the east, and Hooper Avenue on the west. The area gets its name from an early settler, Isaac Osborn, whose children and family became most numerous in the area. Geographically, Osbornville encompassed the area along Drum Point Road from Adamston Road to Hooper Avenue. The first post office here was organized on March 25, 1879, with John W.J. Osborn as postmaster. For a short time, the postal designation was called Osborn, but it was quickly changed to Osbornville. The Osbornville Post Office closed in 1959, when all local post offices were consolidated into one central post office; however, the people living in the Osbornville area were slow to give up using Osbornville, and some residents still use it today as their postal designation, using the zip code for Brick Township.

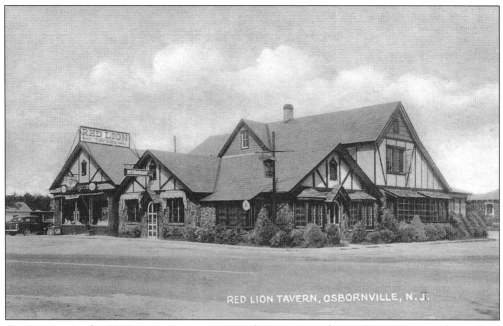

RED LION TAVERN, OSBORNVILLE, N.J.

Starting out in the 1920s as a grocery store and gas station, the Red Lion Tavern, located on the corner of Drum Point Road and Hooper Avenue, was established in 1940 and managed by Joseph and Phyllis McClorry. In 1957, the Citta family took over and expanded the restaurant. Brothers Patrick and Frank Bottazzi purchased the inn in 1977. Frank and his family were the last owners of the Red Lion Inn when it closed in 2012.

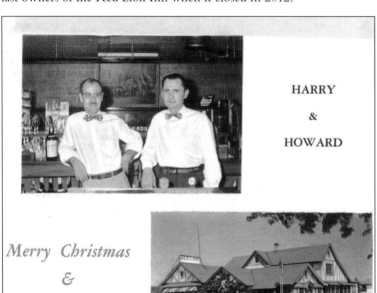

HARRY

&

HOWARD

Merry Christmas
&
A Happy
New Year

Harry and Howard, everyone's favorite bartenders at the Red Lion Tavern, sent out this Christmas card to all their patrons. (Courtesy of Brick Township Historical Society.)

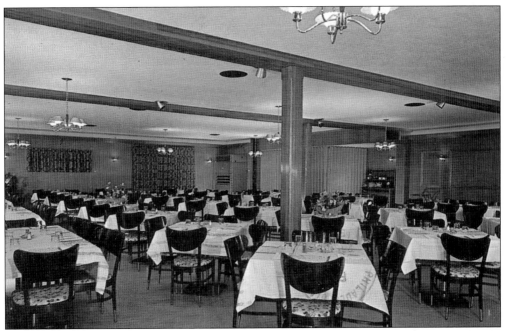

The dining room at the Red Lion Inn was added by the Citta family in 1963. The menu also expanded to include American and Italian cuisine, pizza, and wine and liquor. In the late 1950s, it was one of the few local places to buy a pizza.

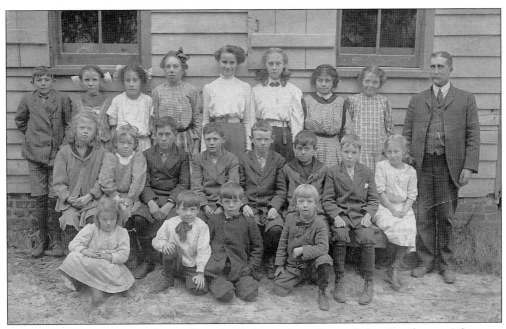

The original one-room Osbornville School, located on Drum Point Road near Adamston Road, was in use from 1870 to 1914. The school housed first through eighth grades. In the fall of 1915, a new four-room school called the Union School opened.

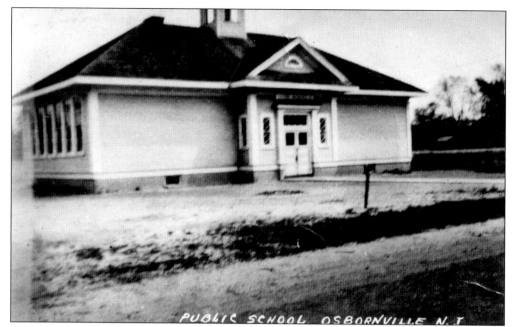

The three-room Osbornville Union School was built in 1915, allowing the district to close and consolidate the old Osbornville and Cedar Bridge Schools. The Osbornville Union School burned down in 1938 and was replaced by the present Osbornville School on Drum Point Road.

In 1938, despite the efforts of the Osbornville, Laurelton, and Mantoloking fire companies, the Osbornville Union School burned down. The board of education placed the loss at between $15,000 and $20,000. That same year, the Osbornville School, seen in this postcard, was built and opened.

A devastating spring forest fire in 1926 was the contributing factor in the formation of Pioneer Hose Company No. 1 in the Osbornville section of Brick Township. Formed in 1927, using a 1927 fire truck, Pioneer Hose Company No. 1 was the first and only fire company in Brick until 1930.

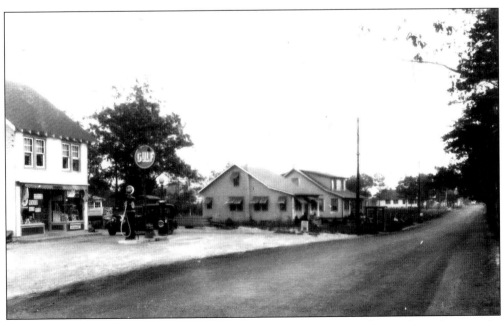

This Gulf gas station on Hooper Avenue was also a food store. Note the two bungalows on the right side of the gas station.

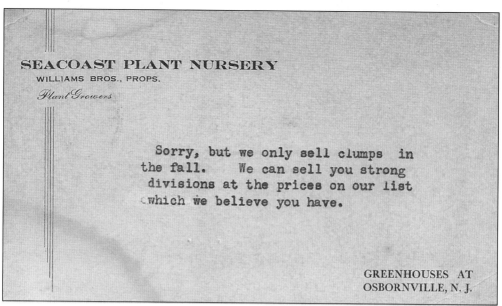

This is a 1941 business card for the Sea Coast Plant Nursery of Osbornville, which supplied garden shops, both local and mail order, with rootstock plants.

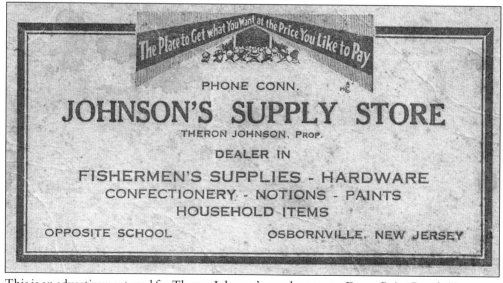

This is an advertisement card for Theron Johnson's supply store on Drum Point Road. (Courtesy of Brick Township Historical Society.)

This is 1950s view of the 15-room Lenape Motel, located at 825 Mantoloking Road near Hooper Avenue. The motel, which featured a swimming pool, advertised its location as close to the beaches on the Metedeconk River.

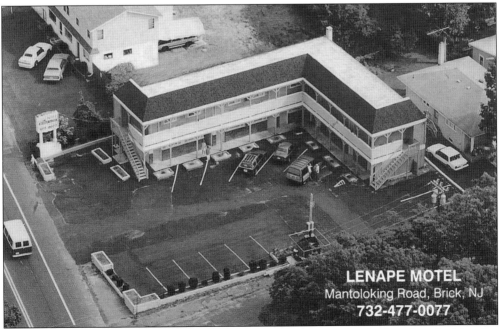

In the 1990s, the Lenape Motel on Mantoloking Road was advertised as "overlooking the scenic Metedeconk River only four miles directly west of the Ocean." The swimming pool is now a parking lot, and a second building has been added in the right rear of the original motel. Rooms are now air-conditioned with cable TV, refrigerator, and microwave oven.

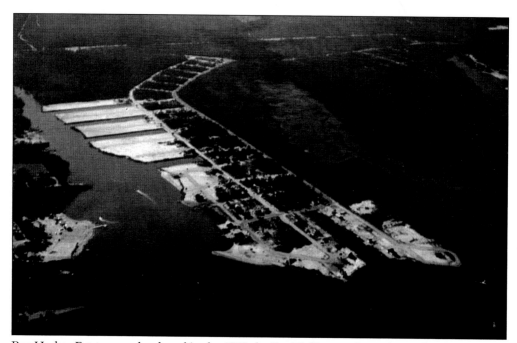

Bay Harbor Estates was developed in the 1950s by Paul Policastro. It was located at the southern end of Brick Township on Kettle Creek and the South Branch of Kettle Creek. Unlike resort communities, it is a residential development, with only those on the waterfront having access to the water.

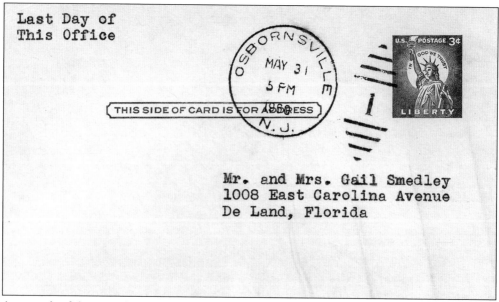

As a result of the consolidation of all the village post offices in Brick in 1959, the Osbornville Post Office issued the last-day postcard on May 31, 1960.

Seven

SHORE ACRES
1948–1961

In 1932, Bert Ward came to Brick Township to build a summer resort community. He purchased low-lying land at the end of Drum Point Road on the shores of Barnegat Bay and Kettle Creek. Ward suffered a setback in 1936 when the building holding his documents burned to the ground. By 1938, Ward's Vanard Corporation was again busy, building lagoons for what Ward called his "boat at door" community. With its network of lagoons, Ward advertised Shore Acres as the "Venice of the Jersey Shore." In 1938, Ward sold eight cottages and 14 cabins and was well on his way. By 1948, the population at Shore Acres had grown to a point where there was demand for a post office. The US Postal Department contracted with Edward Gerlacki to establish a post office in his Shore Acres Plaza, a store on the corner of Drum Point and Mandalay Roads. Most locals called the store Elsie's for the woman who worked there. Edward Gerlacki served as postmaster from 1948 until the post office closed in 1961.

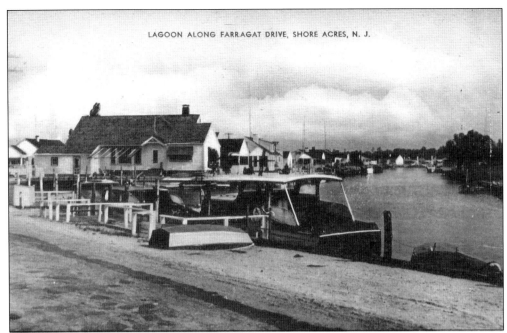

LAGOON ALONG FARRAGAT DRIVE, SHORE ACRES, N. J.

At the end of Drum Point Road stood the sales office for Shore Acres. Written across the roof in large white letters was the word "Office," which was eye-catching when driving down Drum Point Road.

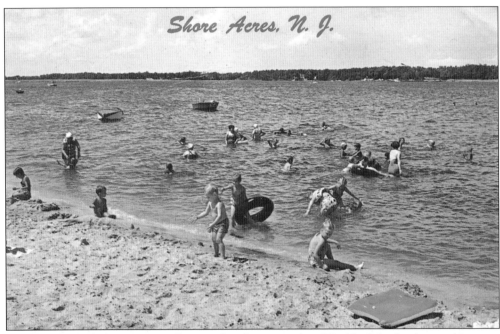

Shore Acres, N. J.

Burt Ward called Shore Acres a "boat at door" community. Ward had dredged several lagoons and used the dredge spoils to fill in the low-lying areas on which to build cottages. The system of lagoons allowed home owners to dock their boats behind their homes. Because the system of lagoons impeded foot access, Ward planned for three beaches.

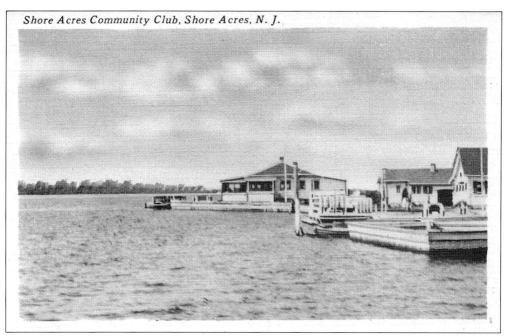

Shore Acres Community Club, Shore Acres, N. J.

It was common at the time for resort communities to have a clubhouse. Since this was a lagoon community, Burt Ward built the Shore Acres Community Clubhouse on a lagoon with access to Kettle Creek.

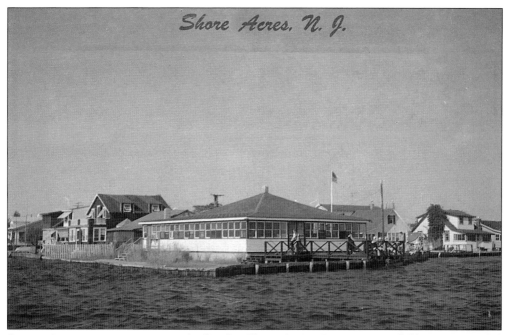

Shore Acres, N. J.

As more summer cottages were built, the Shore Acres Community Clubhouse expanded with an enclosed porch. During the summer months, fundraising activities took place at the clubhouse. There was Breakfast in Hollywood, Tuesday and Thursday were movie nights, and dances were on Saturday nights.

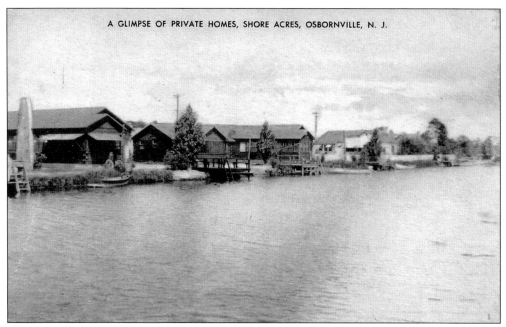

A GLIMPSE OF PRIVATE HOMES, SHORE ACRES, OSBORNVILLE, N. J.

The early photograph on this postcard shows the lagoons not yet bulkheaded. Over time, with the movement of the water due to boat traffic and rainstorms, the banks of the lagoons began to erode, and bulkheads had to be constructed.

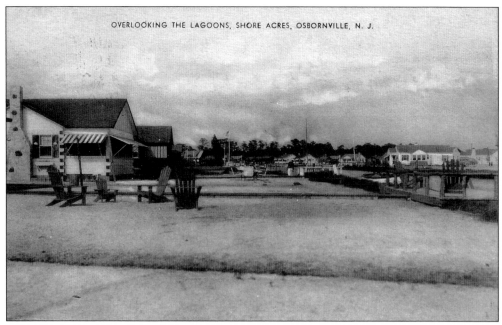

OVERLOOKING THE LAGOONS, SHORE ACRES, OSBORNVILLE, N. J.

The cottage pictured here is built of square timbers in a log cabin style. Also, note the commonly used wood shutters that can be lowered during storms or for closing up the cottage at season's end.

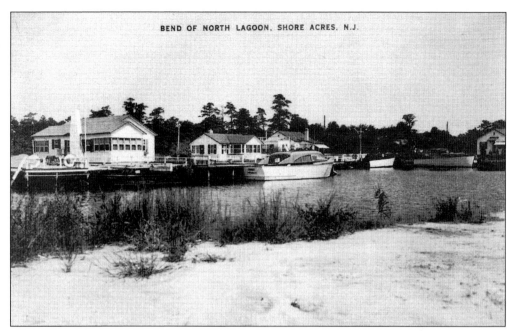

In 1939, Shore Acres was advertised as a "Restricted Club Colony on Barnegat Bay." Residents could boat, bathe, fish, hunt, and enjoy their cottage year-round. A Homestead Special was offered at $1,485 with a monthly payment of $14.50.

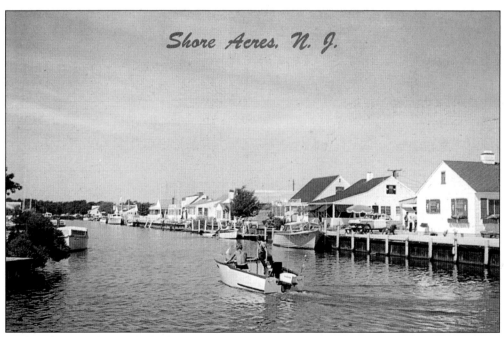

Built at the end of Drum Point Road at Barnegat Bay with an interconnected system of lagoons, Burt Ward's Vanard Corporation advertised Shore Acres as the "Venice of the Jersey Shore."

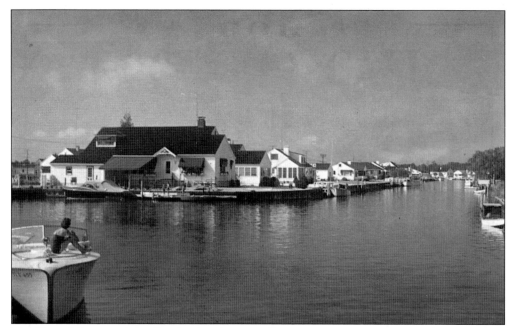

The Vanard Corporation offered prime lots, usually in open-water areas and at the junction of two lagoons or on the bay front. Note the large house constructed where two lagoons meet.

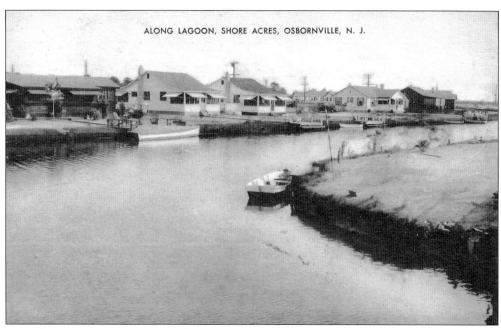

ALONG LAGOON, SHORE ACRES, OSBORNVILLE, N. J.

In 1939, the Vanard Corporation advertised Shore Acres as more than a one-season resort; there was hunting and fishing in the fall, as well as winter sports.

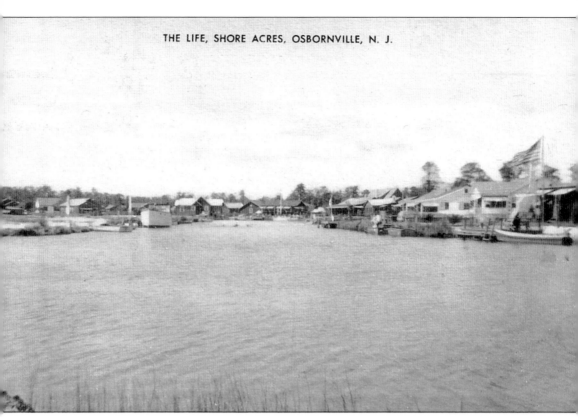

This 1940 postcard shows the rapid growth of Shore Acres since it was first planned in 1932. The postcard is titled *The Life, Shore Acres, Osbornville, N.J.* All mail for Shore Acres came through the Osbornville Post Office until the Shore Acres Post Office opened in 1948.

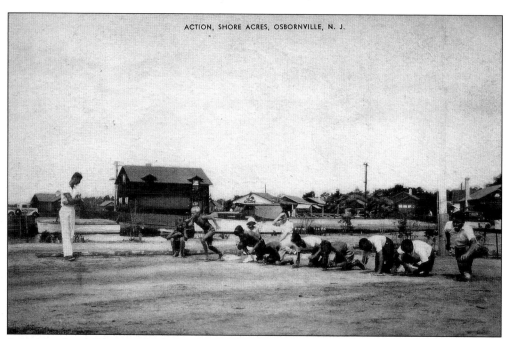

Activities for children took place on a daily basis at Shore Acres. There were arts and crafts, swimming, and sailing lessons. Pictured here is the beginning of a foot race.

Shore Acres, N. J.

There were numerous places along the Metedeconk River, Kettle Creek, and the Manasquan River to rent a boat for a day of crabbing. Whether using traps or drop lines and scoop nets, it was one of the fun things to do in the summertime.

120

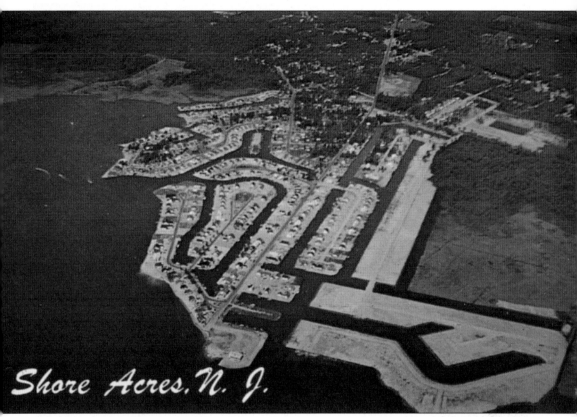

Shore Acres, N. J.

An aerial view from the east shows the interconnected complex of lagoons, explaining why Burt Ward called Shore Acres "the Venice of the Jersey Shore." Much of the land had been created from the spoils dredged from the lagoons.

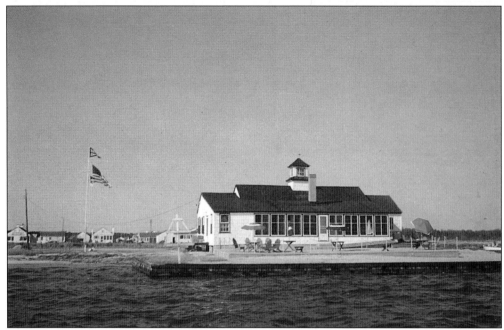

Established in 1940, the Shore Acres Yacht Club is located at the end of Drum Point Road where Kettle Creek meets Barnegat Bay. The club is the center for sailing activities, providing sailing lessons for all age groups.

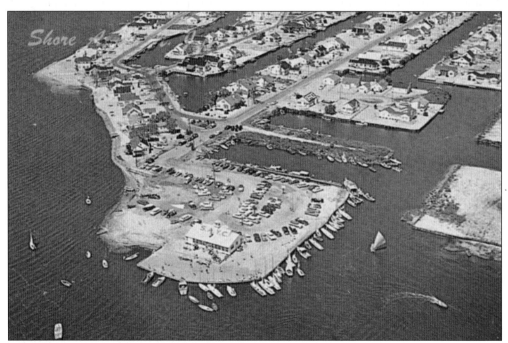

In this aerial view, the boat activity around the Shore Acres Yacht Club can be seen. Besides sailing instructions, the yacht club runs a series of races in the spring, summer, and fall on Saturday mornings and Wednesday evenings.

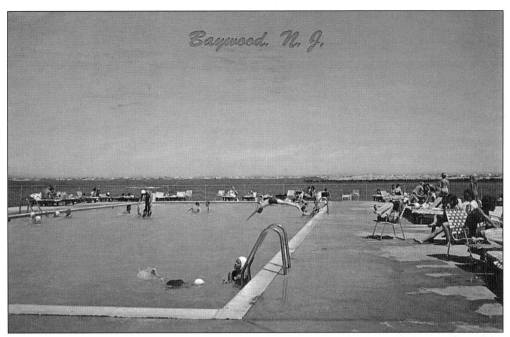

The Van Ness Corporation filed a map to build the Baywood Development in 1956. In the 1950s, the style of the resort community had changed. In Baywood, property owners purchased a lot and brought in their own contractors and plans to construct their homes. There were plans for a recreation area with three swimming pools; however, for various reasons, the land was sold off and a marina and homes were constructed in their place. (Courtesy of Kevin Hughes.)

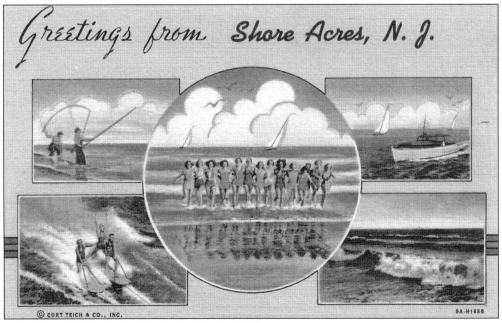

There were several styles of "Greetings From Shore Acres" postcards sold at Elsie's, located at Gerlacki's Shore Acres Plaza store and post office.

This postcard has a hand cancelation stamp from Shore Acres Post Office. This was the last season for the Shore Acres Post Office before it closed in 1961.

Any postcard with Brick Town on it would have been produced between 1959 and 1978. Brick Town was a mailing address created by the US Postal Service when all the local post offices were consolidated in 1959.

Greetings from
Brick Township Beach, N. J.

Brick Township was created by the New Jersey Legislature in 1850 at the same time that Ocean County was created. In the 1960s and 1970s, Brick Township saw its population increase dramatically. During the 1960s and 1970s, the US Postal Service used the postal designation Brick Town for Brick Township, and the new arrivals thought that Brick Town was the name of their new community.

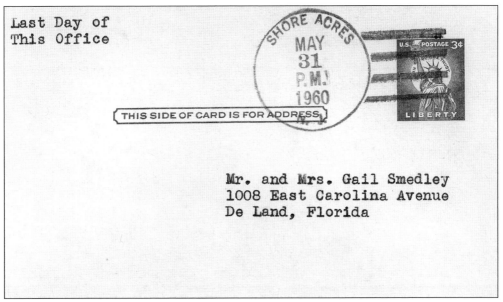

Last Day of
This Office

SHORE ACRES
MAY
31
P. M.
1960
N. J.

THIS SIDE OF CARD IS FOR ADDRESS

U.S. POSTAGE 3¢
LIBERTY

Mr. and Mrs. Gail Smedley
1008 East Carolina Avenue
De Land, Florida

May 31 1960, was to be the last day of service for the Shore Acres Post Office; however, letters and cards were still being canceled into 1961.

BIBLIOGRAPHY

Angott, Eleanor. *The History of Brick Township*. Toms River, NJ: Ocean County Historical Society, 1992.

Campbell, Carolyn M, Perl King, and Martha Smith. *Chickaree in the Walls*. Toms River. Ocean County Historical Society, 1987.

Donatiello, Gene, and John Leavey. *Greetings From Brick Township*. Unpublished.

Donatiello, Gene. *Postal History of Brick Township*. Unpublished.

Miller, Pauline. *Ocean County Four Centuries in the Making*. Toms River, NJ: Ocean County Cultural & Heritage Commission, 2000.

Oxenford, David. *The People of Ocean County*. Point Pleasant Beach, NJ: The Valentine Publishing House, Inc., 1992.

www.aboutusps.com

www.howstuffworks.com/ham-radio.com

BRICK TOWNSHIP HISTORICAL SOCIETY, INC.

On March 23, 1976, the Brick Township Bicentennial Committee founded and organized the Brick Township Historical Society, Inc., as a permanent memorial to the community with the purpose of preserving the history and culture of Brick Township.

Along with sponsoring fundraising events, the society has published several books and pamphlets related to township history. The society has also placed markers at historic sites and houses.

In 1993, Elmer and May Havens donated their family homestead at 521 Herbertsville Road to the Brick Township Historical Society. Society members restored the building and, by 1997, opened the Havens Homestead Museum. The Havens Homestead Museum is a house museum and depicts life in Brick Township as it was in the late 1800s. In 2002, the society moved the c. 1800 Lizzie Herbert house to the Homestead property for use as a museum store. A freestanding two-car garage was converted to a barn with a display of woodworking tools and farm implements. A cranberry shed was added to illustrate the era of cranberry farming in Brick Township. Also on display are a tool shed, a corncrib, and beehives.

The museum is open April through October on Saturdays 10:00 a.m. to noon, Sundays noon to 2:00 p.m., and for special events. The society meets the second Tuesday of January, March, May, June, September, and November at 7:30 p.m. at the Herbertsville Firehouse, located at 601 Herbertsville Road, Brick, New Jersey. All meetings are open to the public.

Please visit the society online at www.bricktwphistoricalsociety.com.

DISCOVER THOUSANDS OF LOCAL HISTORY BOOKS FEATURING MILLIONS OF VINTAGE IMAGES

Arcadia Publishing, the leading local history publisher in the United States, is committed to making history accessible and meaningful through publishing books that celebrate and preserve the heritage of America's people and places.

Find more books like this at
www.arcadiapublishing.com

Search for your hometown history, your old stomping grounds, and even your favorite sports team.